Body Proportions p. 12
 Babies & Kids p 13
Eyes p 22
Sea Gulls p 74

Bluebist Monks p 76
Japanese Cleaning Ladies 77 + 137

Market Scene 136 106 & 107

Sheep 92

aughted Salt ladies p 8 p 31 p68

Putting People
In Your Paintings

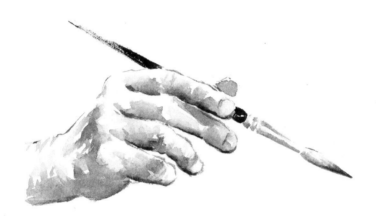

Putting People In Your Paintings

J. Everett Draper

North Light Publishers

Acknowledgments

My sincere thanks to David Lewis for organizing the presentation of the text and illustrations, to Fritz Henning for encouraging my concept along the way to book form, and to Pete Mandell for helping with the writing and editing.

Published by North Light, an imprint of Writer's Digest Books, 9933 Alliance Road, Cincinnati, Ohio 45242

Manufactured in Spain.
First Edition

Library of Congress Cataloging-in-Publication Data

Draper, J. Everett.
 Putting people in your paintings.

 Bibliography: p.
 Includes index.
 1. Human figure in art. 2. Painting—Technique.
I. Title.
ND1290.D73 1985 751.4 85-15399
ISBN 0-89134-162-5

Dedicated with love to Evelyn
— and to Pam, Dick and
grandson Bill.

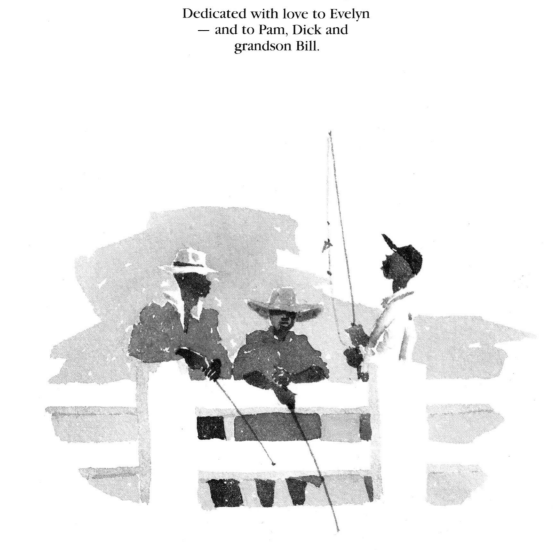

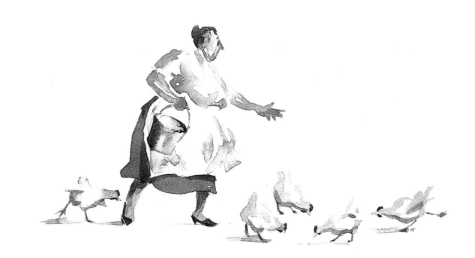

Contents

Introduction

Many of the participants in watercolor workshops I have conducted here and abroad have one characteristic in common. They need to learn an effective, practical way to include human figures in their landscape paintings without undoing the rest of their effort.

Trees, rocks, old barns, and other subjects in the general landscape category are, from the standpoint of drawing, most forgiving as subject matter. However, the day inevitably comes when an artist is confronted with a scene whose essence is the colorful activity of the people involved.

The scene could be a marketplace in Mexico or the sardine fisherman on the beaches of Portugal. Whatever or wherever it may be, such a painting can represent frustration if you lack an understanding of drawing and painting the figure.

For such artists, I hope this book will fill a need. We will not concentrate on the study of anatomy, or give serious instruction in how to produce works where the figure is the major element of the painting. Rather, the emphasis is on simple, achievable suggestions of figures.

The goal is to help the serious amateur painter produce small or medium-sized figures that are incidental to the picture's composition, rather than being its main focus. Without dealing with complexities, I hope to provide the basic knowledge of figure construction enabling you to produce competent figures that will add life and interest to your paintings.

Throughout these pages you will find an assortment of small watercolor figures. They may or may not relate directly to the text on the particular page where you find them. Their purpose is to provide you with an inventory of figure studies as reference for your own paintings. It is hoped that these examples, plus earnest experimenting and persistence on your part will add to the usefulness and enjoyment of your picture making efforts. That is what this book is about.

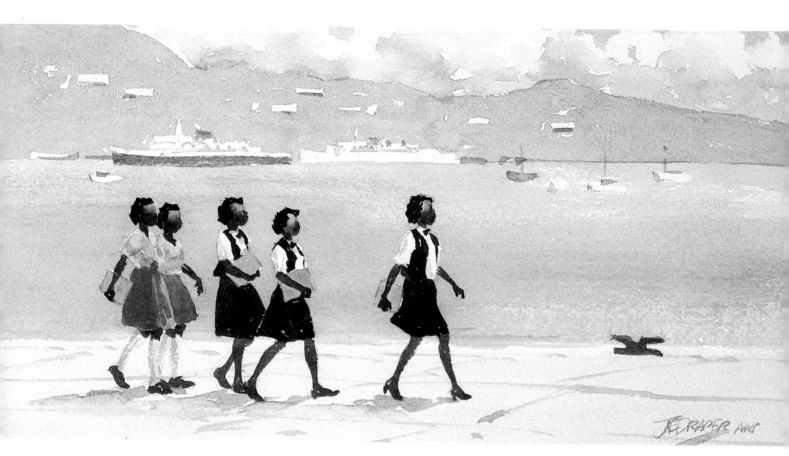

Schoolgirls, St. Thomas
5½ x 11 inches
These schoolgirls in their neat uniforms caught my eye as a possible painting. The figures are mostly from memory and the background based on a slide. This is only a sketch which someday may become a painting.

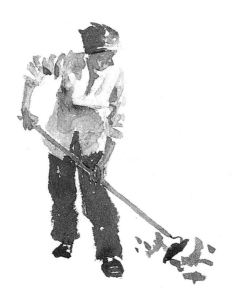

Introduction to the Figure

Learning all the bones and muscles for the purpose of painting or drawing the figure can take years of study and practice. Obviously this is not practical if you simply want to be able to include a small figure or two in a landscape without spoiling your painting with a misproportioned representation of a human being.

My purpose is to enable you to produce simplified and simply executed figures for your paintings.

In the interest of simplification, you will take many shortcuts, concerning yourself only with the obvious visible effects. Proportions are the most important considerations, followed by topographical or superficial anatomy, then action. We will also briefly consider some of the more essential and visible details of anatomy, since you must have at least a basic familiarity with whatever is being simplified.

Small figures in a painting can be represented in many different ways. Sometimes a simple stroke of paint will do the job, but more often the suggestion of a figure requires some indication of gesture and proportions.

No matter how small or insignificant a figure is in a painting, if it doesn't read as a figure, it can spoil the entire work. The most common faults of a poor figure are bad proportions and incorrect action.

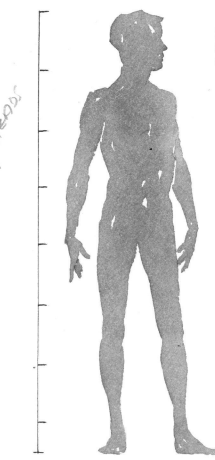

7 Heads

Here are some good reference points to remember for the average figure. Measuring from the head down:

shoulders at 1⅓ heads

elbows at 3 heads
navel at 3 heads

crotch at half-way point

fingertips at 4½ heads

knees at 5½ heads

These reference points are not based on precise measurements. They will vary from individual to individual. As your eye for figure proportions develops you will begin relying on your own judgment rather than measurement.

Using the above chart, one part of the figure can be compared in size to another part and used as a check when the figure is drawn in various positions.

Proportions

Whenever or however the figure is represented, correct proportions become all important. A figure is recognized first as a shape which should convey the identity and the action. If the shape is misproportioned, quick recognition is likely to be lost.

Probably the most important proportional element is the size of the head. With wrong head sizes, figures may appear grotesque and distorted: adults are apt to look like children and vice versa.

The first key then is to properly relate the figure proportion to the head size. The established norm for the average figure is seven-and-one-half heads tall. This is the proportion favored by many artists, especially illustrators. It represents an idealized figure, a little taller than what we might consider an average person to be.

In reality, most of us are about seven heads tall or less. Obviously some people will have shorter, heavier-set figures of about six or six-and-one-half heads as their body lengths. On the other hand, fashion artists often use eight, nine or

even ten heads to produce a supposedly more glamorous, stylized figure. In attempting to create an heroic figure, sculptors may also employ exaggerated proportions.

When learning the idealized proportions of the body beautiful, we should keep in mind that such proportions are not the kind most of us have. However, such standardization is helpful in establishing the illusion of young adults.

As middle age comes along, all kinds of things happen to many figures. The old proportions are still there, but somehow camouflaged by extra padding. In capturing the middle-aged figure, your task is to hang those extra pounds and other ravages of the years on that same basic skeleton that lies underneath.

With the passage of even more time, additional changes occur in the figure structure. The elderly body often becomes slightly bent and loses the erect stance evident in younger years. Over the decades, gravity also exerts its toll on the figure, resulting in sagging flesh, settling bones, and inevitable wrinkling.

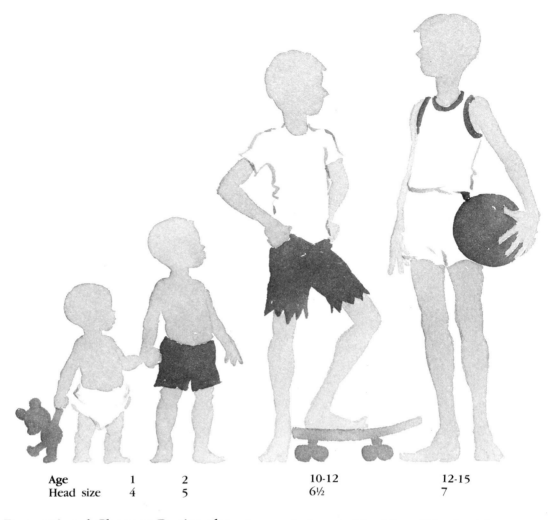

Age	1	2		10-12	12-15
Head size	4	5		6½	7

Children: Proportional Changes During the Growing Years

When the task is representing children, we should contend with proportional changes as they grow from infancy to adulthood.

Again, the head size is most important. The head used as a unit of measurement changes considerably with growth.

All during this time, of course, everything else is growing as well, but at different rates. The arms and legs grow faster than the torso, for example. Because of this, growing youngsters tend to develop a gangly "all knees and elbows" look.

These uneven rates of growth are not restricted to human beings. It is true of animals. Observe the frisky colt in the pasture and the wobbly-legged fawn in the woods on page 81.

Generally speaking, a figure can be made to look younger by increasing the head size slightly. A precaution would be to avoid making necks and shoulders too heavy and muscular-looking. This kind of heaviness occurs gradually as the young person achieves adult proportions.

In general, the year-old toddler will be about four heads tall. As the body becomes larger in relation to the head during growth, the body will go through stages of being five heads tall at age three, six-and-one-half heads tall at age ten to twelve, and seven in the early teen years. With a little further growth, he achieves the proportions of an adult.

13

The proportions of the head also change during growth. The baby's cranium and facial area, measured vertically, are about equal. During growth to adulthood this proportion changes with the facial area becoming greater than the cranium.

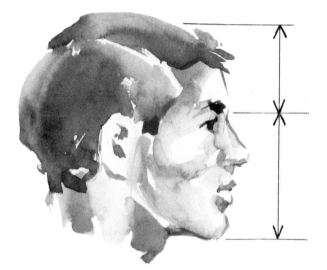

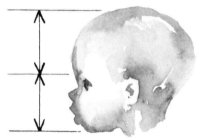

Proportions of the human figure will vary at times in the individual, of course, but we can accept the information above as a general guide for the small figures we will be doing.

There will be chubby children and skinny children, but most active children will tend to keep standard body proportions during their growing years. The important facts are that they are young, active, and full of life. These are the qualities to be captured in your drawings.

Figure Action

Most of the figures in your paintings probably will not be shown in violent actions. Usually, walking or moving about in process of their daily activities would be the extent of the action evident in a painting not depending on figure dominance. However, showing any kind of movement correctly requires some knowledge of how the parts of the body interact in normal motion.

As shown in the figure diagram on page 15, one of the basic facts controlling the attitude of the figure in motion is that the pelvis and the lower spine join rigidly at right angles. This means that when the pelvis tips because the weight of the body is on one foot or the other — the spine must also tip. To recover, the upper spine (being flexible) bends in the opposite direction to keep the body in balance.

As a result, the shoulder line tips in the opposite direction from the pelvic line. This condition is always present as the body moves. If the pelvis tips one way, the shoulders tip the other way.

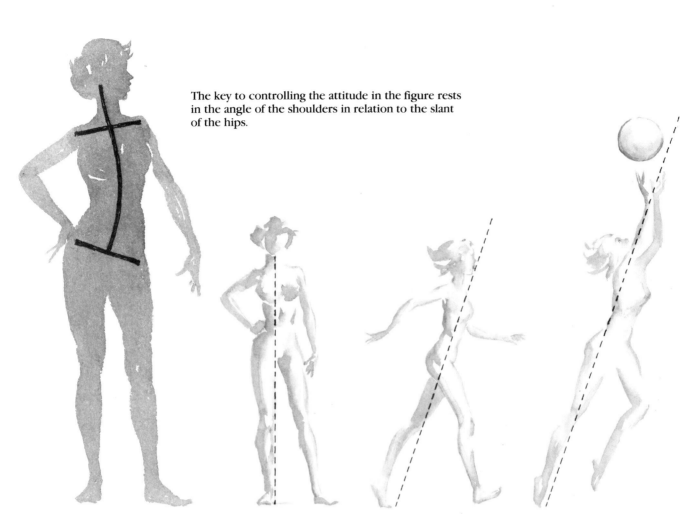

The key to controlling the attitude in the figure rests in the angle of the shoulders in relation to the slant of the hips.

The other figures demonstrate that the action line in a figure in motion tips in the direction of the movement. In the standing figure, this line is vertical and indicates the center of balance. In walking or running, the figure is always in the process of falling forward, with each forward step preventing the fall.

In the walking or running figure, another important bit of action to represent correctly is the alternating swing of the arms in relation to the step or stride of the legs. When the right leg swings forward, the right arm swings back. This alternating movement and rhythm keeps the figure in balance as it moves. (Try running or walking rapidly, and swing your arms and legs on the same side backward and forward at the same time. You'll find it quite difficult and awkward to do.)

Simple skeletonized brush figures or stick figures can be a big help in visualizing the figures you want. After sketching the pose of the figure, see if your roughed-in figure can contain the correctly proportioned skeletonized figure.

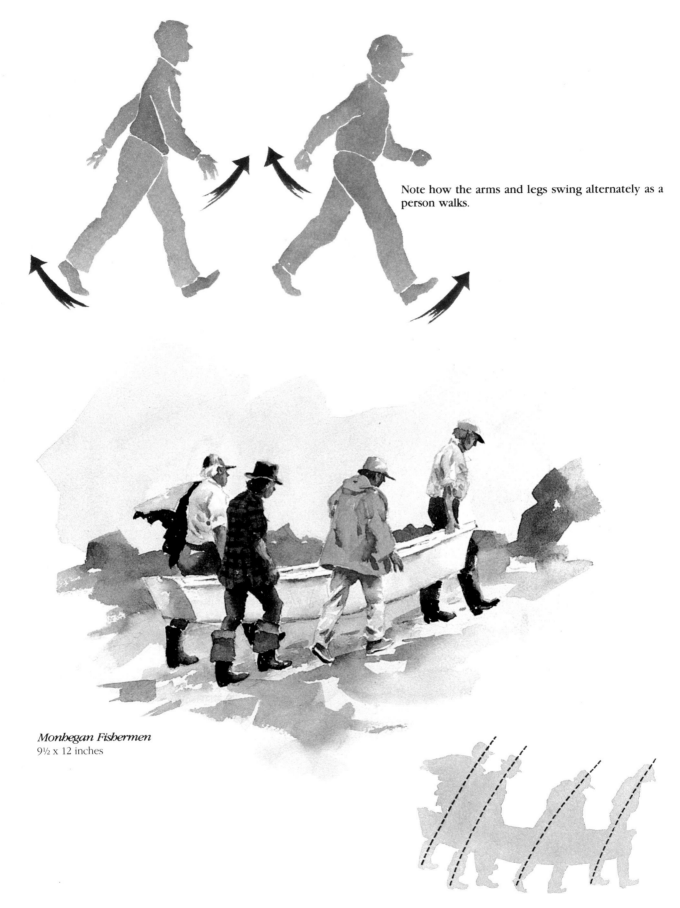

Note how the arms and legs swing alternately as a person walks.

Monhegan Fishermen
9½ x 12 inches

The diagram shows how the action line is present and working in this painting.

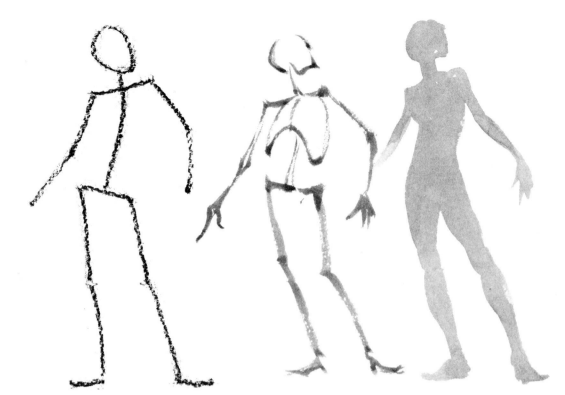

If proportions don't look quite right try using a
skeletal or stick figure as a check.

Simple stick figures are a good means of visualizing
action and proportions. The stick figure—or a very
simplified, skeletonized figure, as shown here—is
the best way to start the figure. At this stage, you
can check for correct proportions and determine if
the action of the figure really works.

 Since stick figures tend to be stiff, it is a good
idea, once the action and proportions are
satisfactory, to rework a figure's pose as a gesture
drawing. This should be done loosely, and at first,
without rigidly following the stick figure. You will
probably have to do a number of gesture figures
before getting a satisfactory feeling of loose,
flowing action. When you think you have achieved
this effect, double-check the gesture figure against
the original stick figure for proper proportions and
adjust where necessary.

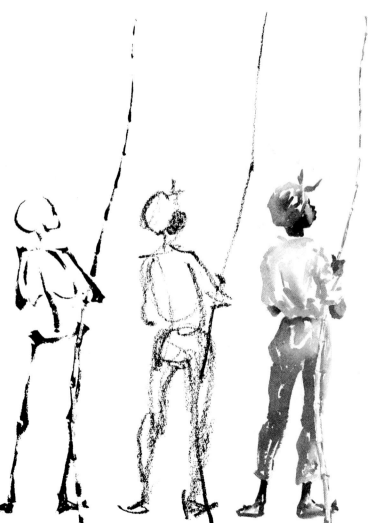

The gesture sketch (one of many)

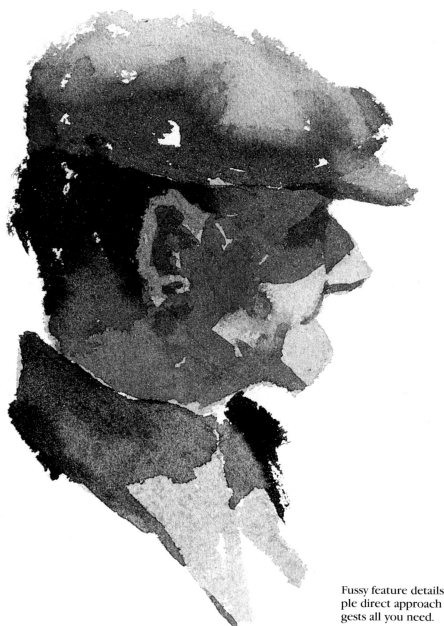

Fussy feature details are seldom necessary. The simple direct approach with a broad brush usually suggests all you need.

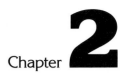

Figure Details

No matter how much you downplay detail, it can still make an impact in the way each small part relates to the whole. Each detail plays its part in contributing to the effectiveness of the gesture and action. Your drawing will benefit from your knowledge of the figure's bits and pieces, even though they are only minimally represented. And the simplification called for will be much more successful if you have an understanding of the detail you are simplifying.

For the sake of clarity, most of the illustrations in this chapter are larger and involve more detail than you normally will be using, but this additional knowledge should lend authority to your figures.

Let's take the example of hands and feet. Even though they may be represented by a small blob of paint or with a tiny flick of the brush, they can look wrong if they are done without some basic knowledge of how they are constructed. A little knowledge can rescue an artist who otherwise might have to cop out by putting his figure's hands in his pockets or have him standing in tall grass or a cloud of dust to hide his feet.

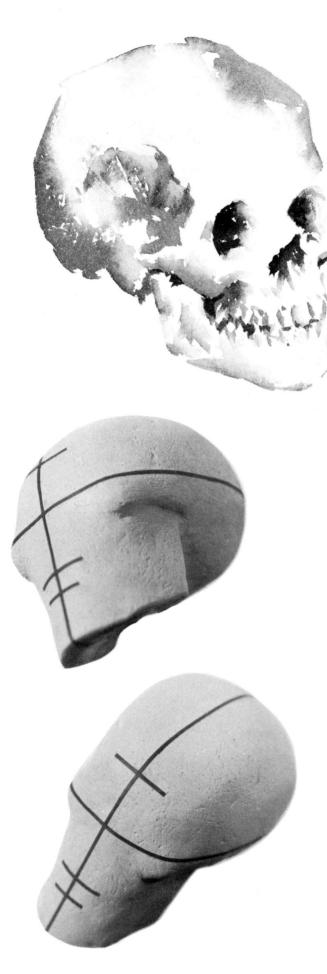

The Head

The basic shape of the head is often referred to as "egg-shaped" or "a modified sphere." This terminology and subsequent construction has never worked for me. I prefer to call and think of heads as "head-shaped." The heads shown here are merely the shapes of simplified skulls. I don't believe that it is too complex a shape itself for anyone to understand.

These illustrations show that shape from several angles. Practice making drawings similar to these before attempting to deal with features. As an aid, why not model a lump of clay, or work a couple of your kneaded erasers into this head shape? Studying it in three dimensions makes it even simpler to understand.

Practice drawing this shape until drawing it from all angles becomes almost second nature. Then you will be ready to work with features.

On the left is a small clay model (about the size of a baseball) I made. I baked it in the oven and then marked off the proportions with tape. From this model, it is possible to produce correct placement of the features when the head is at any angle.

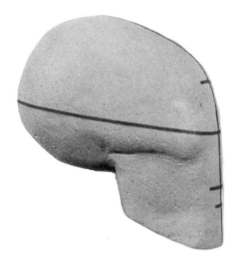

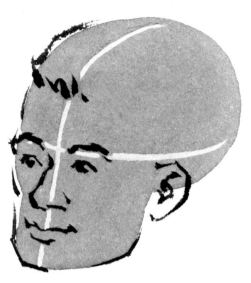

Once these lines have been established, features can be placed in the correct positions.

Features

The features establish the identity of the figure. Their individual variations are endless. The following pages show the construction of the individual features and a small sampling of the variations.

Make it a practice to observe and study individuals around you. Sketching as you go will increase your mental inventory of variations and sharpen your awareness of the unique shapes that make up noses, eyes, ears, chins, lips, and brows.

Locating the features correctly is the first consideration. The illustrations show the guidelines for their positioning.

The facial area is divided roughly into thirds, from the forehead hairline to the chin. The first third locates the brow, and the second third locates the bottom of the nose. The mouth is down about one-third of the distance between the nose and the chin.

Note that the top of the ear is level with the brow, and that its bottom is level with the bottom of the nose. The front edge of the ear is found at the halfway mark from the front to the back of the head.

These are rough measurements based on a straight-on view, and they won't hold with every individual. They are given here simply as guidelines and to give you a safe starting point for your drawings.

From a straight on view the features are easily placed by dividing the head into thirds.

Note that the eye is always a sphere.

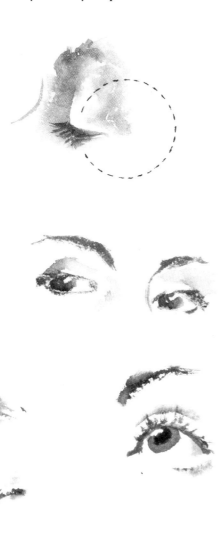

The Eyes

At this point, you can begin to consider the features individually. As you study the various features in detail, always remain conscious of how their construction, from a drawing standpoint, must conform to the drawing of the whole head.

The eyes are the most expressive of all human features. Without help from other features, they can indicate pleasure, sadness, fright, fatigue, or pain.

In small figures, the eyes may often be no more than simple brush marks, but even such a mark can and should indicate an emotion or mood.

You have drawn the skull shape and marked off the positions of the brow, the bottom of the nose, and the mouth. The next step is drawing the eyes.

To do this successfully, you must think of the construction of the entire eye. It consists of a spherical shape, enveloped and protected by movable upper and lower lids and placed in the eye socket, an indentation in the skull. The underneath presence of the eyeball gives the eyelids their contour. The eyebrow generally conforms to the upper edge of the eye socket.

Our drawing of the eye will be a drawing of the eyelids and brow, but the underneath presence of the spherical eyeball gives the lids their contour.

In any larger figures, it would be wise to lightly sketch the eyeballs in their sockets and then draw the lids and brows, making them conform to what is underneath.

Many things contribute to the variations in the appearance of eyes. Age is one factor; for example, visualize the smoothly formed eye of a child as compared to the accentuated lines of an elderly person's eye, or a woman's eye versus a man's. Racial characteristics play a part also, as in the case of the full Oriental upper lid.

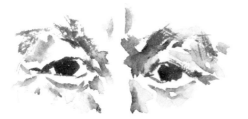

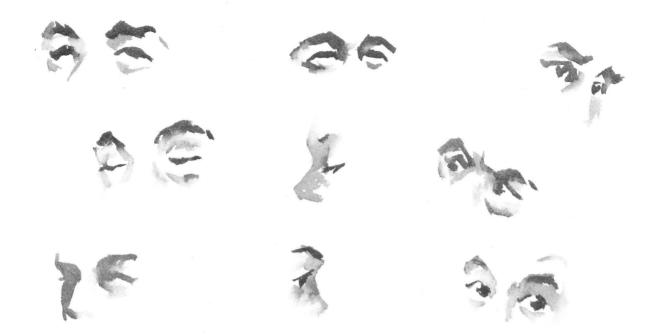

Practice working directly with a No. 4 brush to capture the character of these eyes. First brush in the general eye area. Then add the accents of eye detail with darker strokes.

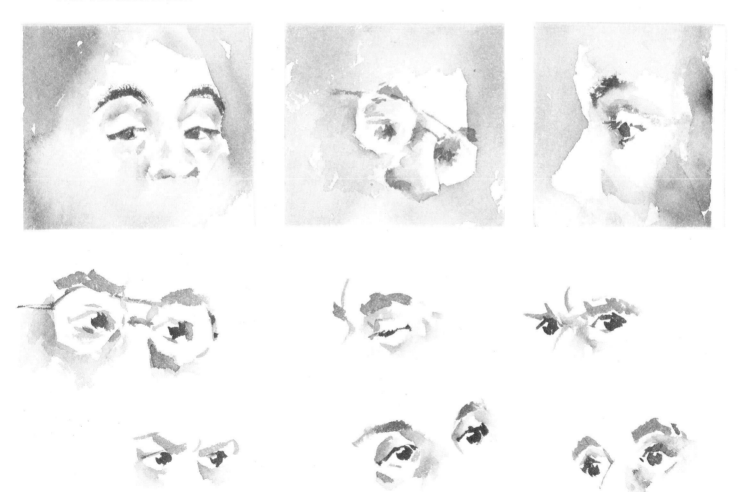

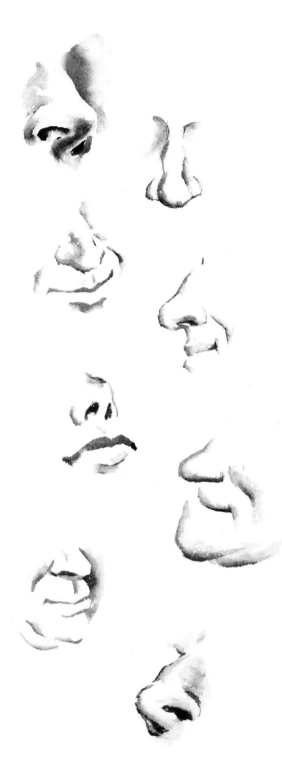

When drawing a nose, imagine it as a three-dimensional structure with these planes.

The Nose and the Mouth

The nose is a three-dimensional structure, but beyond some flaring of the nostrils and a little wriggling, it is not capable of much movement or animation. However, as with all the features, very few are exactly alike. There is so much variety that you might think it would be impossible to draw a nose incorrectly, but unfortunately such is not the case.

The basic structure of the feature is shown here, along with a few variations. The relationship of the nose to the mouth is important — the reason why the two features are shown together here.

The mouth is capable of more movement than any of our features and does more to convey expression than any other. The form of the lips in repose should be studied before trying to cope with their considerable range of movement and change. The opening and closing of the mouth involves the movement of the jaw and this adds movement to the face as well.

With all of the movement, it is easy to lose sight of the all-important bone structure underneath. As you draw, make sure that the presence of the jawbone and the rest of the skull is apparent. In addition, study the characteristic patterns of the folds and creases surrounding the mouth and chin as illustrated on these pages.

Practice drawing noses and mouths like this, paying special attention to the variety of shapes. Remember that it is the nose, the upper-lip area, the mouth, the chin, and the cheeks _together_ that give expression to the lower part of the face.

When making wash studies of mouths and lips, try
to be aware of the three-dimensional form.

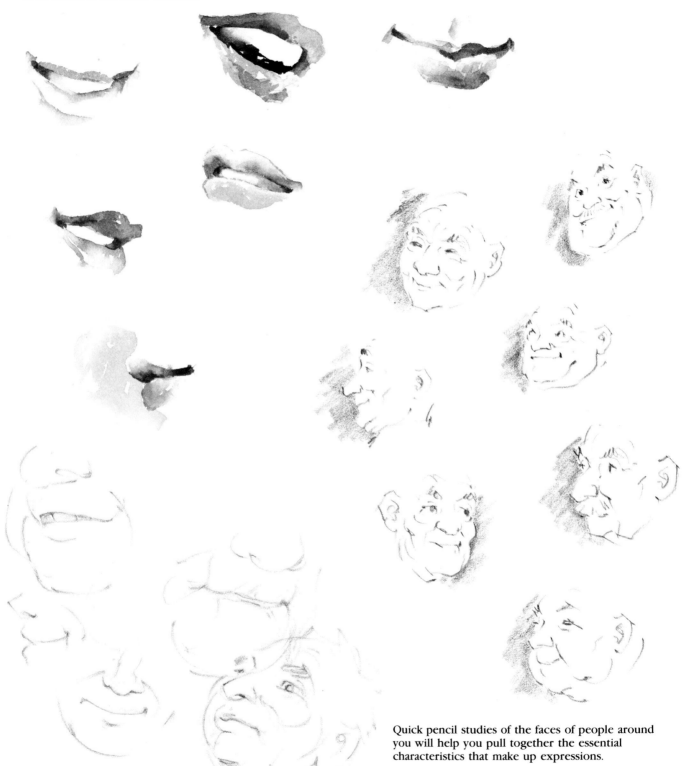

Quick pencil studies of the faces of people around
you will help you pull together the essential
characteristics that make up expressions.

25

The Ears

As far as movement and expression are concerned, ears don't do much. They don't contribute to expression like the eyes and mouth, but they can help spell out the general character of the figure in subtle ways. In any case, whenever they are shown, they should be drawn carefully.

Norman Rockwell made great use of ears to characterize some of his figures. In a rear view, you could often tell what kind of character he was depicting by the way he drew the ears.

In our small figures, the important things to note about ears would be locations, shape and size, in addition to the angle at which they are attached to the head.

The convolutions within the ear are confusing to some, but a close look shows most to have a simple pattern. In spite of individual variations, this pattern is always present.

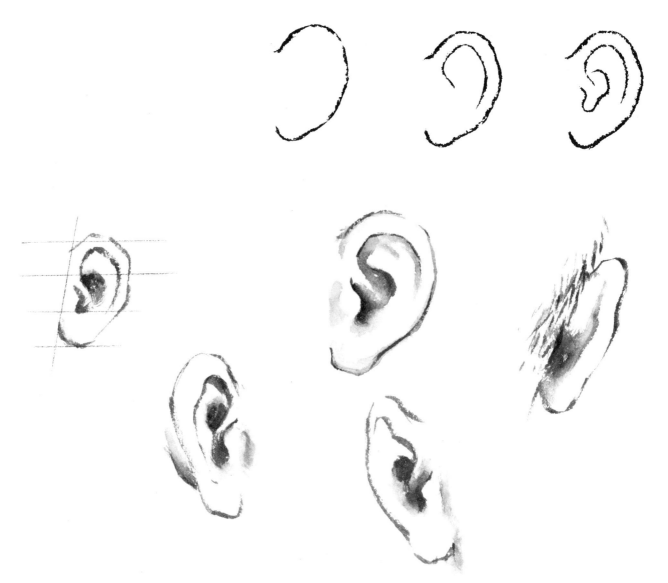

The Head—Putting it All Together

Let's go back to the simplified skull on page 20.

Think of it as the simplified skull shape, as described, and think also in terms of representing it in simple light-and-shade modeling.

Study the heads on these pages and note how this simple modeling is broken up by the intrusion of features. A nose, for instance, catches light and interrupts the shading. Other features, as the position of the head changes, can do the same thing.

Remember, small figures will have small heads, so their modeling and detailing should be kept utterly simple. Often, just the shape and attitude of the head can describe a person more accurately than any amount of detail.

Simple modeling with light and shade is usually all that is needed. Just paint the shadow pattern and forget the detail.

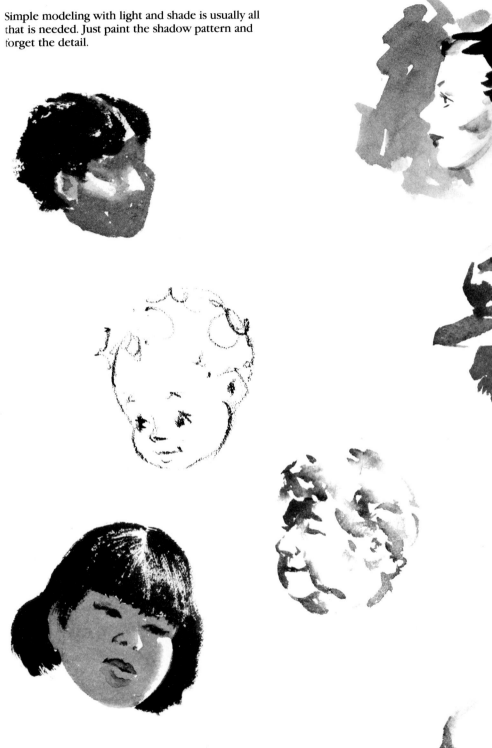

The head with all its individual parts is the most important portion of the figure to suggest effectively Whether large or small in your painting, the head requires careful consideration.

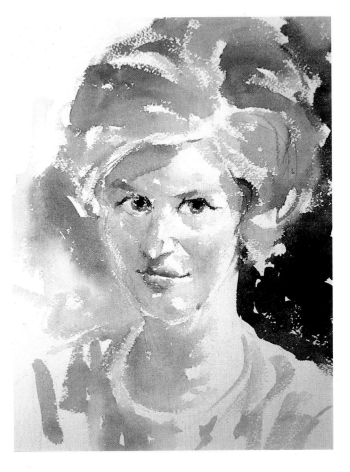

Pam
15 x 11½ inches
This is my daughter. It is a quick sketch that turned out to be more of a caricature than a portrait. Although she's really much better looking, this simple statement is quite a good likeness.

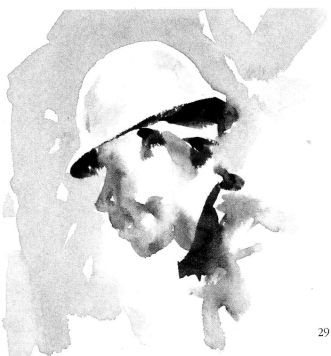

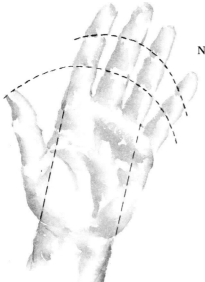

Note how the knuckles align with each other.

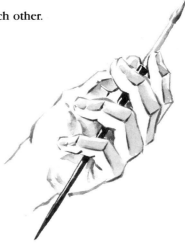

Note also that the wrist is approximately as wide as the first three fingers and aligns with them.

Observe the three-dimensional construction of each individual finger.

The hand's attachment to the wrist has a slight offset rather than being a straight extension of the arm.

Study your own hand and note that the palm is much longer than the back of the hand. Notice the position of the knuckles in relation to the corresponding creases on the underside of the fingers.

The Hands

The hand is very complex and hard to draw. In addition to its many functions, it plays an important part in contributing to the gesture of the entire figure.

The hand might seem to be such a small detail on the figures you are doing that its anatomy may not seem necessary to study. However, a tiny blob of paint representing the hand, if done without knowledge, can make the figure appear to have a broken wrist or to be wearing a catcher's mitt. Your tiny flick of the brush that creates a hand can contribute to the gesture of the figure or defeat it.

The diagrams shown here illustrate a few simple facts of the hand's construction.

For practice try using a mirror on a wall in front of you as a means of drawing your own hand that is making the drawing. Your drawing should show an awareness of the bones in the hand.

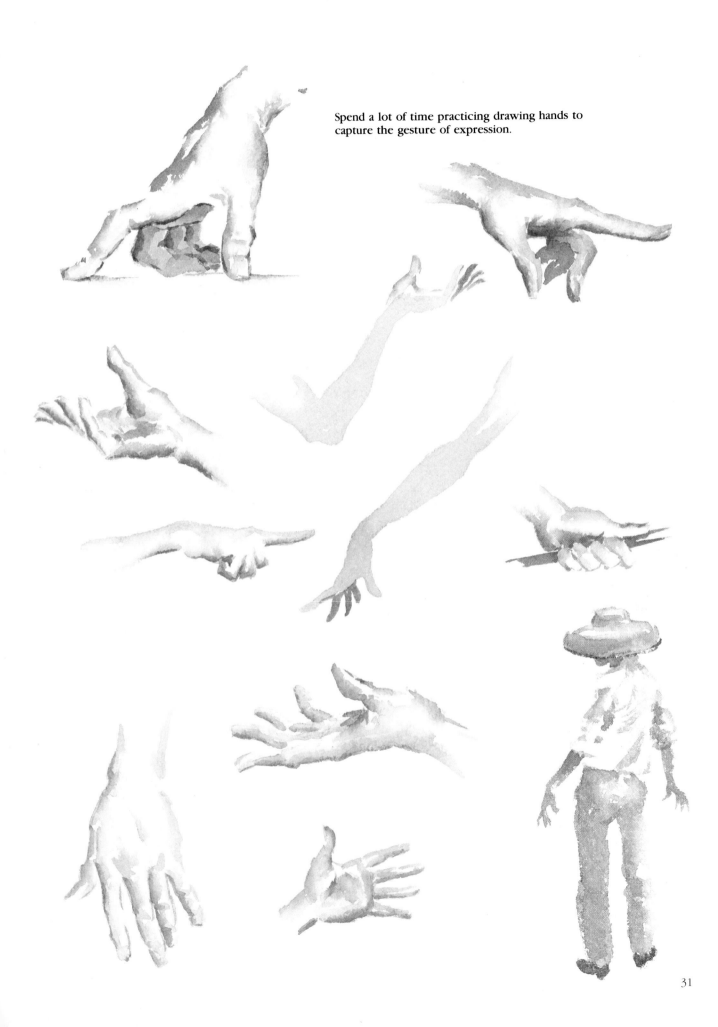

Spend a lot of time practicing drawing hands to capture the gesture of expression.

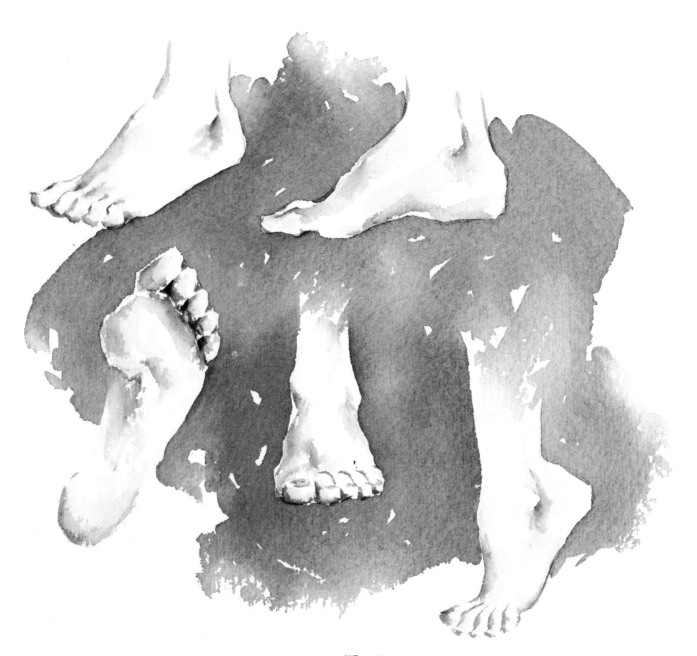

The Feet

Feet are just as hard to draw as hands, although they are not usually as much in evidence as the hands. Furthermore, they are frequently in shoes — which are not that easy to draw, either.

Feet, of course, are important when depicting the figure in action. In walking, running and many other actions, the observer should be able to see what the foot is doing as it propels the figure on its way.

When the figure is at rest, the position of the feet also contribute to the general expression. In other poses — active or static — the feet can help to convey a required mood. In their own way, feet add almost as much to the gesture of the figure as the hands.

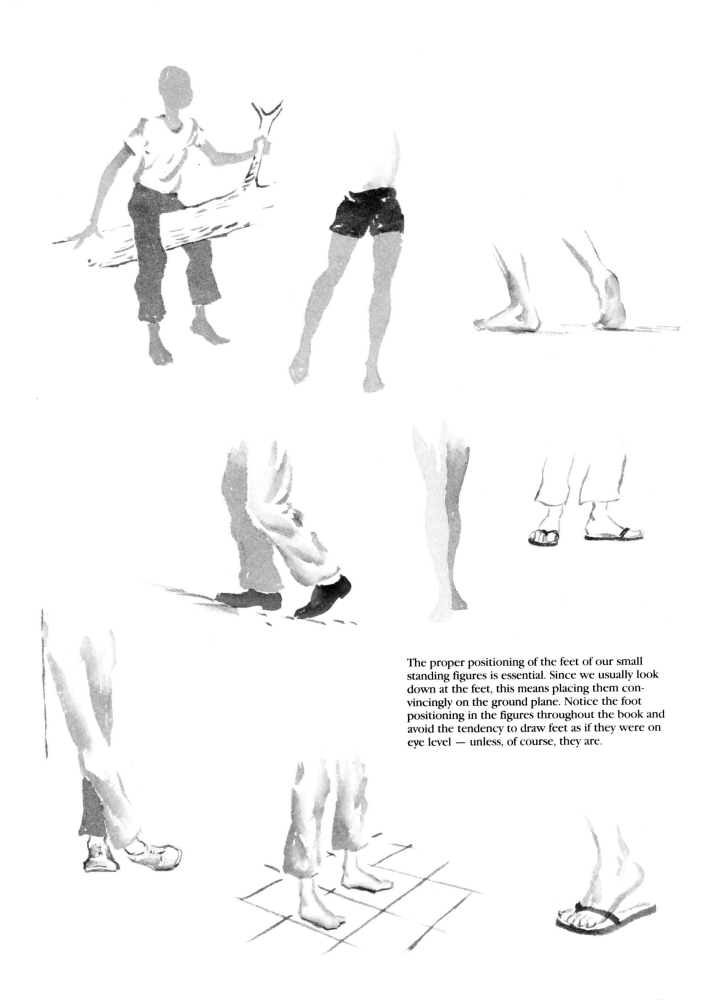

The proper positioning of the feet of our small standing figures is essential. Since we usually look down at the feet, this means placing them convincingly on the ground plane. Notice the foot positioning in the figures throughout the book and avoid the tendency to draw feet as if they were on eye level — unless, of course, they are.

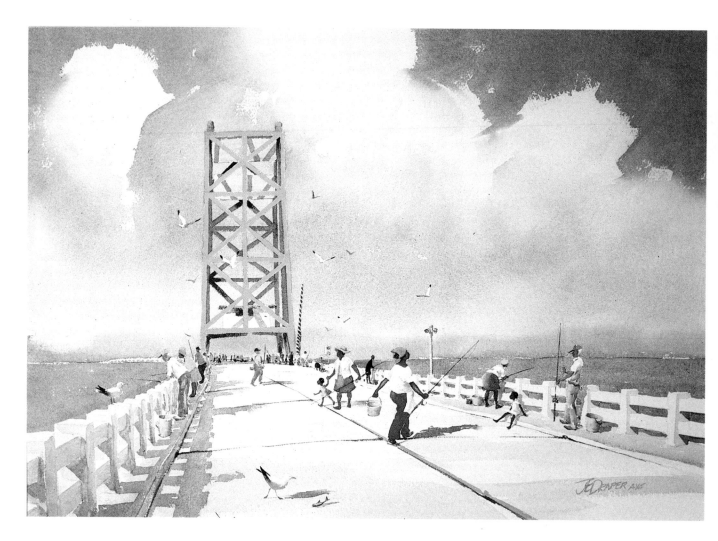

Vilano Bridge

21 x 29 inches

Collection of Mr. and Mrs. Jack Proctor

In the past, bridges lined with people fishing were a commonplace sight in Florida. Now, bridge fishing is generally prohibited, and catwalks below road level and out of sight have been constructed for the anglers to use. Such prohibitions need not deter the artist. In this case I took matters in my own hands, and painted the bridges and supplied my own people, based on my sketchbook file.

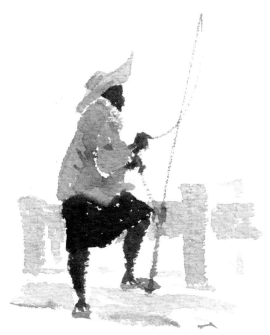

The Whole Figure

Now that you are armed with an assortment of figure facts, it is time to try creating your own figures. As you begin, think of the small figures as contributing detail to a painting without the necessity of their being detailed themselves. They are to provide the suggestion of detail which often is all that is needed.

Since you are not now concerned with the whole painting, but only the small figures in it, there is no need to discuss paper or materials. The decisions to use 300 lb. rough, or 140 lb. cold pressed or whatever, and what pigments to use, will already have been made. Things discussed about figures in this chapter will apply, regardless of what mediums or materials are used.

We will be talking mostly in terms of watercolor, although the execution of these figures does not depend upon any particular medium. When discussing procedures, it will be mostly from the standpoint of maintaining a feeling of looseness and spontaneity.

The stage of your preliminary drawing becomes all important at this point. It can be quite simple, perhaps little more than a stick figure, but it should enable you to objectively check for correct proportions and action. As time goes on (and with practice), your eye for correct proportions and action will develop, along with your ability to produce good figures.

The practice of preliminary drawing is a discipline which may go against the grain of some artists who would rather just pick up the brush and let things happen. This is a lot more fun and promotes spontaneity. Nevertheless, I believe in craftsmanship and even while allowing the watercolor to do its own thing, I feel there are advantages when you stay in control.

Creating the Figure

As you start to create your own figures, you'll find yourself contending with the changes that clothing makes in the overall silhouette of the figure. The original proportions are still there, but disguised by a series of new shapes. It becomes necessary to learn about these shapes, since it is the clothed figure that is your concern.

A method of studying that works is to find magazine or newspaper illustrations that contain full figures. With a brush and ink, black in these figures, making silhouette shapes. Study these shapes carefully and, using them as guides, create brush-and-ink shapes of your own, making sure that the shapes you create contain correctly proportioned figures.

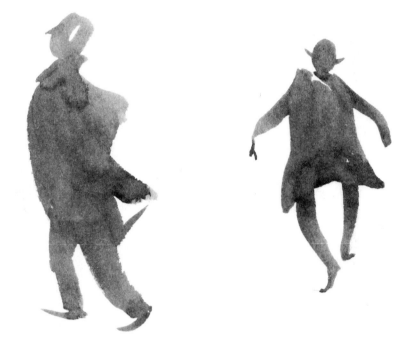

Believable figures depend on the shapes you build. In addition, the movement of clothing is often helpful in emphasizing the action of the figure. Study these three figures and notice that the movement of the clothing affects the shape of the figure in action.

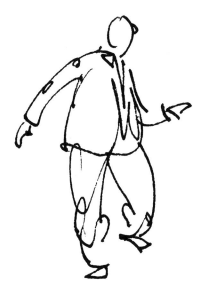

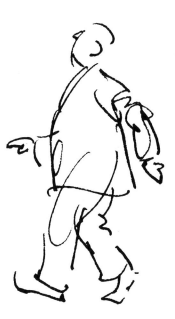

The gesture drawing is the essence of the figure's action; try to find any dominant line that depicts this. It doesn't have to be complete or anatomically accurate. Put down whatever you see as suggesting the movement. Often, it is the clothing rather than what is under it that shows action.

Gesture Drawing

The study of figure shapes leads to gesture drawing. The approach to gesture drawing is to catch the action and the general character of the figure with a few essential strokes. Let your pencil roam at will to describe the action. Be concerned with what your subject is doing rather than its static shape. Don't be concerned at this point with details of shapes or figure structure. As the fine teacher Kimon Nicolaides put it: "Gesture has no precise edge, no exact shape, no jelled form."*

Brush and watercolor, soft pencil, ball point or fountain pen. All are capable of the loose, flowing line wanted for gesture drawing. Use any tool that gives you an easy response and with which you feel comfortable.

* *The Natural Way to Draw* by Kimon Nicolaides, Houghton Mifflin Co., Boston © 1941

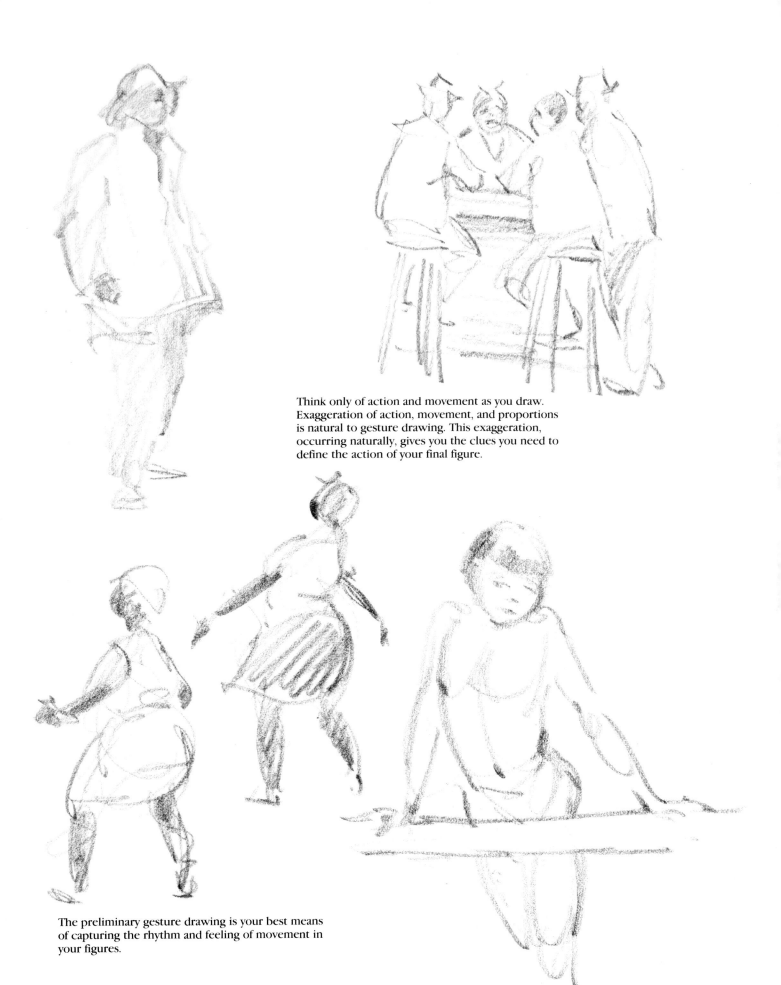

Think only of action and movement as you draw.
Exaggeration of action, movement, and proportions
is natural to gesture drawing. This exaggeration,
occurring naturally, gives you the clues you need to
define the action of your final figure.

The preliminary gesture drawing is your best means
of capturing the rhythm and feeling of movement in
your figures.

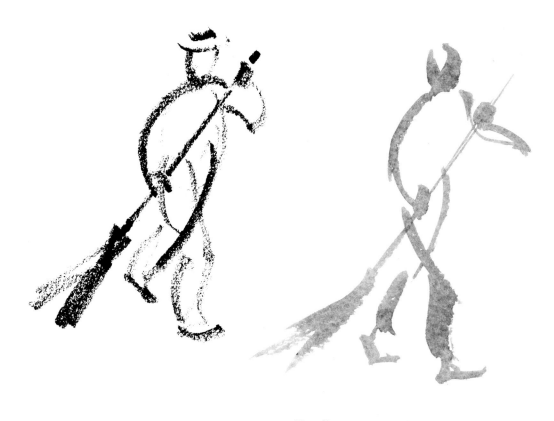

Not all your gesture drawings will be successful. Just keep turning them out until one has the look, the feel that pleases you.

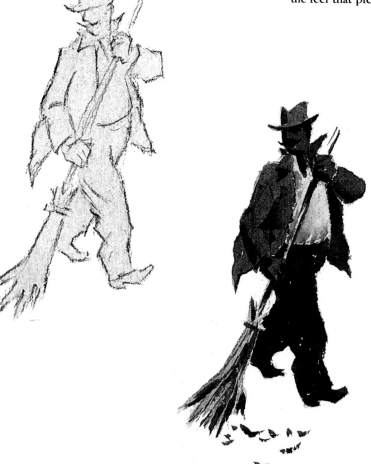

This Mexican street sweeper is an example of a backlighted figure. He would be used against a light background and be more or less silhouetted. For this reason, the entire figure is given a medium value before any details are painted in. Any white of the paper showing on the figure would be an incorrect value.

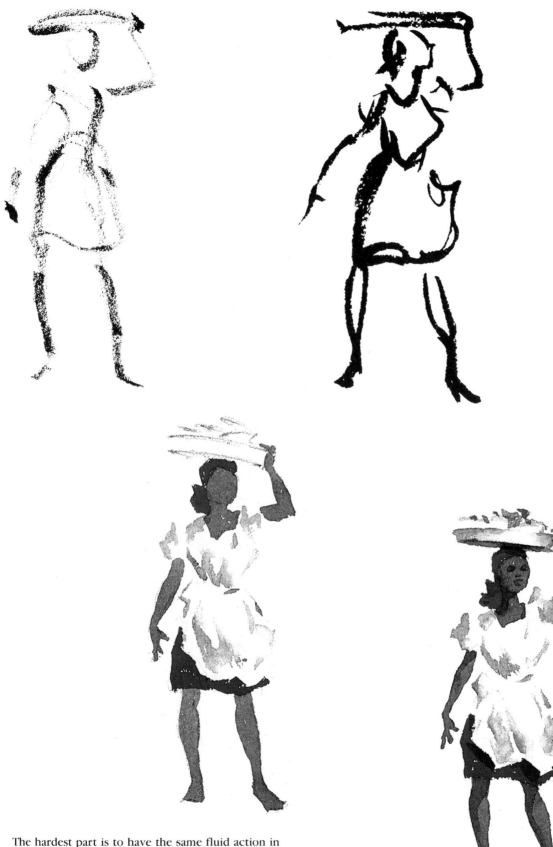

The hardest part is to have the same fluid action in the final figure that you caught in the gesture sketch. Don't give up: the more you persevere, the more success you will have and the more your talent will develop.

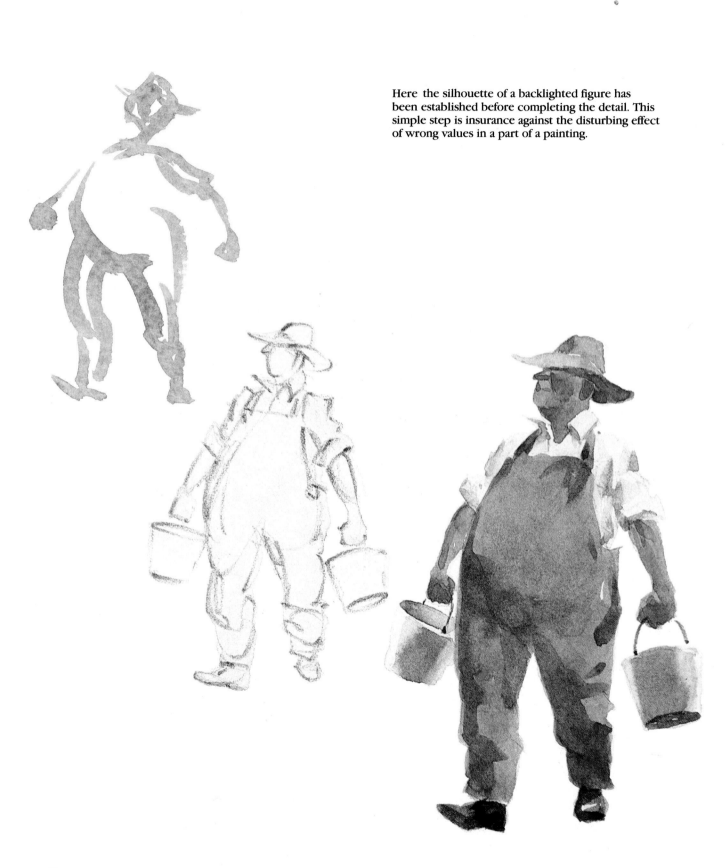

Here the silhouette of a backlighted figure has been established before completing the detail. This simple step is insurance against the disturbing effect of wrong values in a part of a painting.

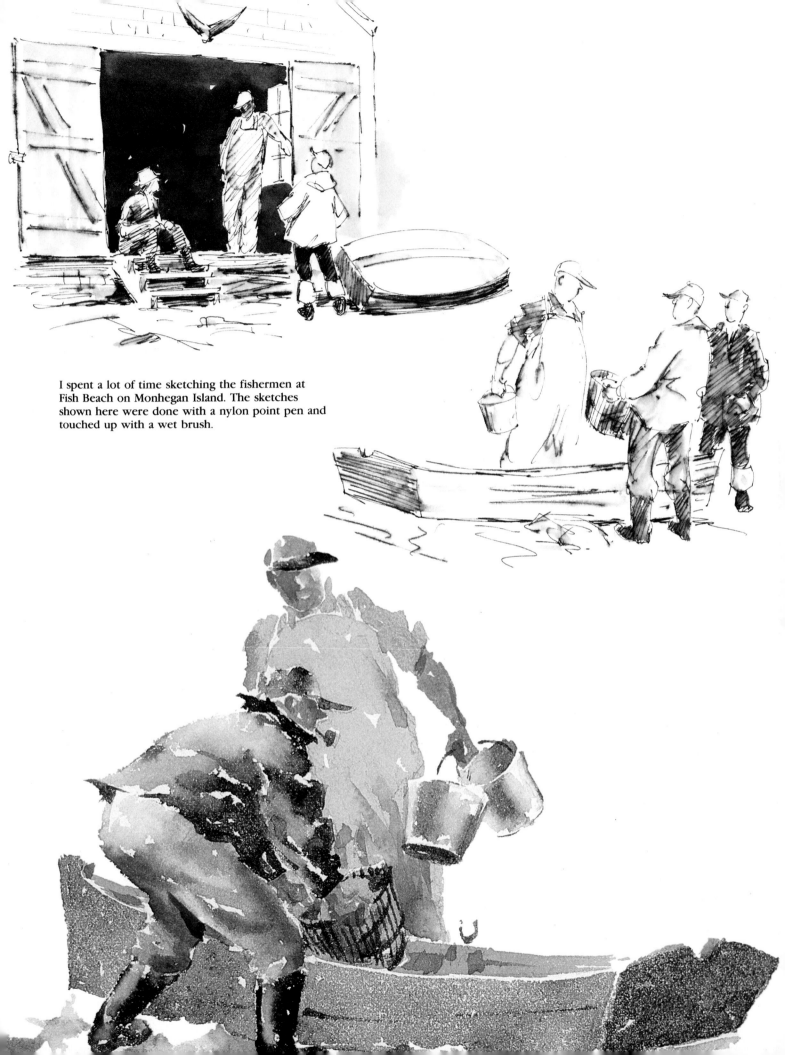

I spent a lot of time sketching the fishermen at
Fish Beach on Monhegan Island. The sketches
shown here were done with a nylon point pen and
touched up with a wet brush.

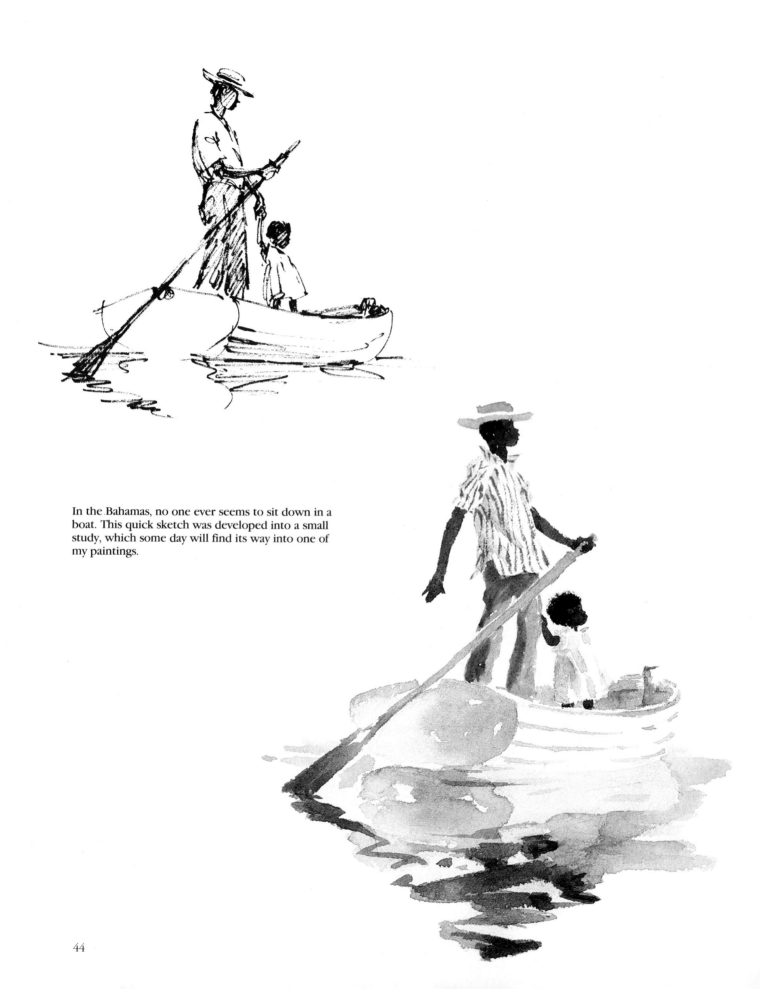

In the Bahamas, no one ever seems to sit down in a boat. This quick sketch was developed into a small study, which some day will find its way into one of my paintings.

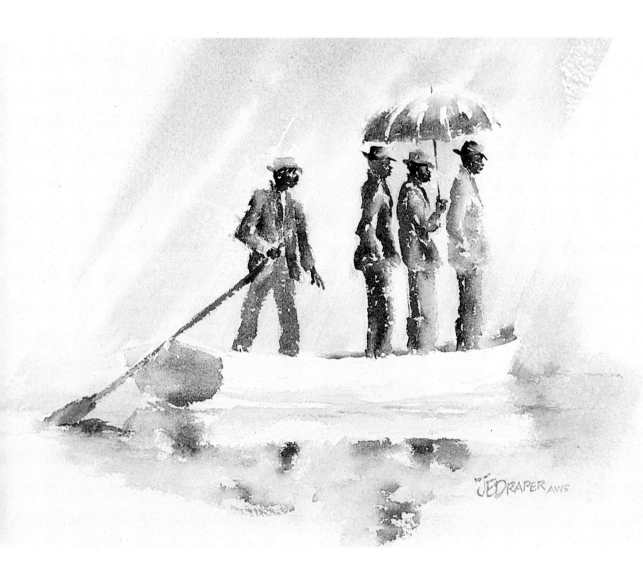

Nassau Water Taxi
10 x 14 inches
These Nassau water taxis never seem to want for business as they carry crew members ashore and back to their ships at anchor in the harbor.

 This was started on wet paper and finished as it dried, allowing the sparkle of white paper to suggest the wetness of the figures.

In this sketch, assume you have established the horizon and key figure. Now, you want to place the other figures in the composition and have them properly relate to each other. Mark their positions (as in the small diagram) and then determine their sizes by means of lines from their location to the key figure, and then on to the vanishing points on the horizon. Each new figure can become the key for another figure. Note how a shorter person's figure was established and then used as a key figure for the other figures.

Using the Figure

When putting figures into a painting, two things are of utmost importance. One is their placement from the standpoint of composition, and the other is sizing the figure correctly.

Placement is a matter of design. Whenever a figure (or any other element) is introduced into a painting, it creates space division, a fundamental of composition. This is discussed further in Chapter 5. For now, we'll turn our attention to establishing the sizes of the figures in a composition.

The size of a single figure in a painting is usually determined by relating it to another element of known size in the painting. This is seldom a problem for any artist with a reasonably good eye.

Problems can arise, however, when there are other figures at various locations, ranging from the foreground to the background. If these figures are not related to each other properly, you can easily end up with an assortment of dwarves and giants dotting your landscape.

Once one figure has been sized by eye, the task is to relate the other figures properly to the key figure and to each other.

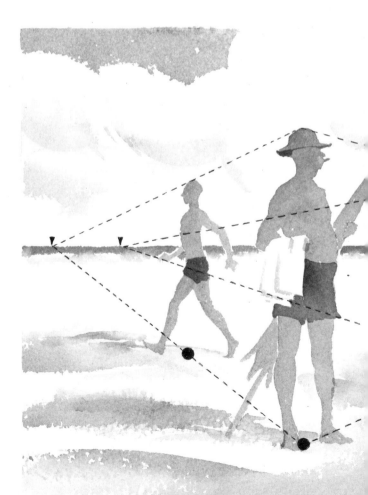

Sizing by Perspective

The sizes of related objects (such as figures) at various locations in the painting are determined by perspective. The term *perspective* has a formidable reputation among many artists because it is thought of in terms of the complicated procedures used in architectural rendering.

For our purposes, however, we'll dispense with complexities in favor of a simple process of relating figures to the horizon.

First you should know that every painting will have a horizon, or more accurately, a given eye-level. In art terms horizon and eye-level are considered synonymous. A key fact to remember is that the horizon line represents the eye-level of you, the observer. If you are observing the scene from an elevation, the horizon will be high on your paper. If you are seated, as at the beach, it will be low.

The horizon may be obviously visible (as in a scene at the beach), or it may be invisible (as in the case of an interior, or hidden by trees or mountains). Visible or invisible, it is always there, and all the elements in your painting will relate to it.

You will notice that when your eye-level is low, the horizon crosses the standing figures at a low section of the body, say, the knees, since this is approximately your eye level. When all the figures in your picture are on the same level and are all about the same size (this seldom happens of course), the horizon line will cross each figure at about the same point — be it the knees, the navel, or wherever.

When the terrain is uneven, with some figures on high ground and others on low, you can establish a figure's size at one level, and then raise the measurement vertically to another.

I have illustrated a method of using one key figure as a starting point. Then, by means of lines to and from vanishing points on the horizon, you establish the sizes of figures at other locations.

Another method is to use multiples of any figure dimension (such as the head) to determine the distance from the horizon. This procedure will automatically determine the figure's size at the same time, a convenient method when the horizon is high. It can be used also by measuring downward, when a low horizon is used.

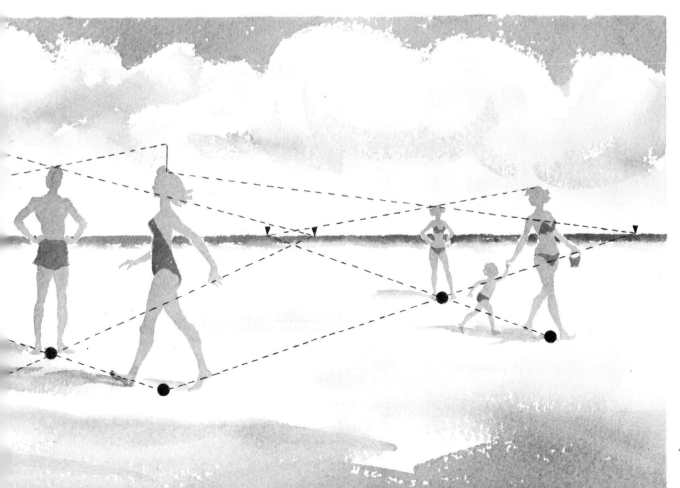

On a level plane the horizon cuts all figures at the same place.

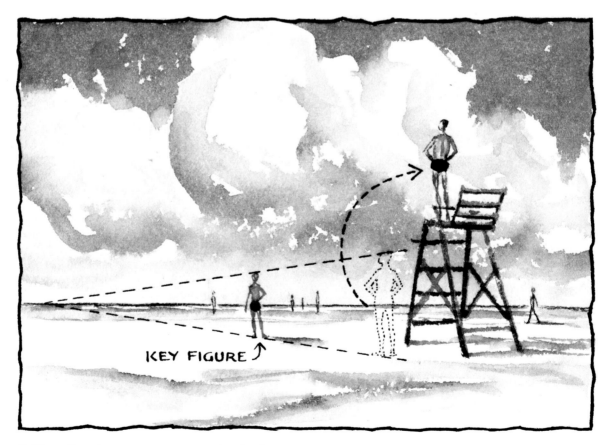

KEY FIGURE ↑

Raising a figure's measurement to another level.

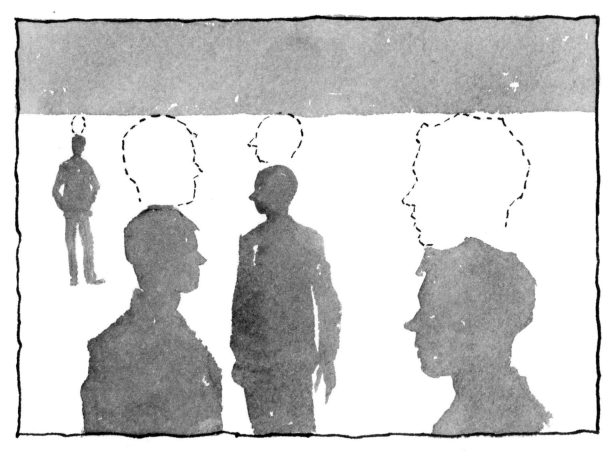

Another way to determine relative figure sizes is to use multiples of any figure dimension (in this case, the head) as a standard of measurement.

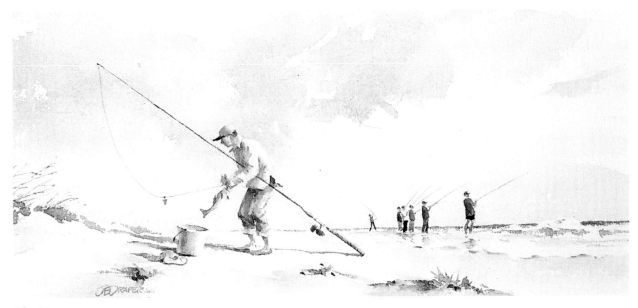

The Hotspot
7 x 15 inches
Notice how this low eye level has the horizon crossing everyone's legs below the knees.

Drawing

Good drawing is the foundation of good painting and is especially important when dealing with the figure. Whether the painting is a simple figure or a complex scene, the drawing stage should never be slighted. The amount of preliminary drawing that is put into a painting will vary greatly, depending upon your ability and, to some degree, the subject matter.

When I am painting simple and familiar subjects, I often lightly indicate the size and position of the elements and then accomplish the final drawing with the brush. This is not generally recommended, however, except when a totally simple and loose effect is desired.

When your subject has any complicated detail or depends upon correct perspective, it will be necessary to put extra time and effort into the drawing stage to assure a solid foundation for the painting to come. At such times, in order to save the wear and tear of erasures on the watercolor paper, I find it advisable to work out all the drawing problems on a large tracing pad, then transfer the results to the watercolor paper.

A possible problem with this approach is that concentrating on tight drawing can lead to a painting that looks overly controlled. As I see it, such an effect is an undesirable condition. However, once the drawing is down with all the drawing problems solved, I find I can paint freely, simplifying and even eliminating some detail as I go. When painting loosely over a tight drawing the finished painting will look loose and spontaneous, even though the drawing wasn't.

Function

Any figure in a painting, however it may be used, will have a strong tendency to call attention to itself. In a painting where the figure is intended only as an incidental element, its attention-pulling power can detract from, as well as add to, that painting.

Waitresses on a Break, Jamaica
21 x 14 inches
Looking at a scene from an elevation gives us a high
horizon. Notice also the complementary color
scheme. The predominately green setting
emphasizes the reds of the waitresses' uniforms.

Therefore, care should be used in the placement
of a figure in your compositions. In addition, the
figure's attention value can be used to perform
useful functions without its being the focal point
of the painting. Along with other means such as
strong contrasts of values or shapes, it can be
used to help draw attention to some important
area.

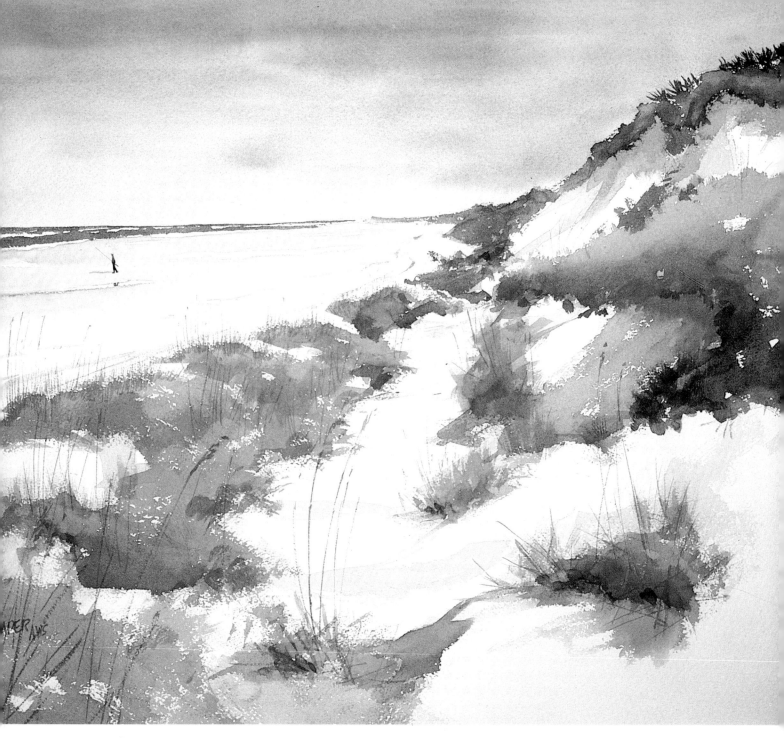

Ponte Vedra Beach
21 x 29 inches

Notice how the surf fisherman adds interest, and to
some degree, establishes a locale. Without the
figure, this could be any deserted beach in any
part of the world. Its size emphasizes the great
expanse of this particular beach at low tide. In this
case, the figure also performs the important
function of establishing scale.

Scale

Many familiar things exist in a wide range of sizes. In a painting, an uncommonly large object will come across no differently than one of normal size, unless there is a size reference. To show how big or small an object is, it has to be shown in comparison with something else of an accepted, known size. The figure can often play that part.

An example is the huge propellor of a super-tanker in a Newport News, Virginia drydock. Without the figures, the propellor could be that of a much smaller vessel.

When using the figure to establish scale, a little exaggeration is excusable — even desirable. A case in point is the painting I called *Tarzan* on pages 56-57. Without the small boy's figure, the huge size of the banyan tree would never have come across.

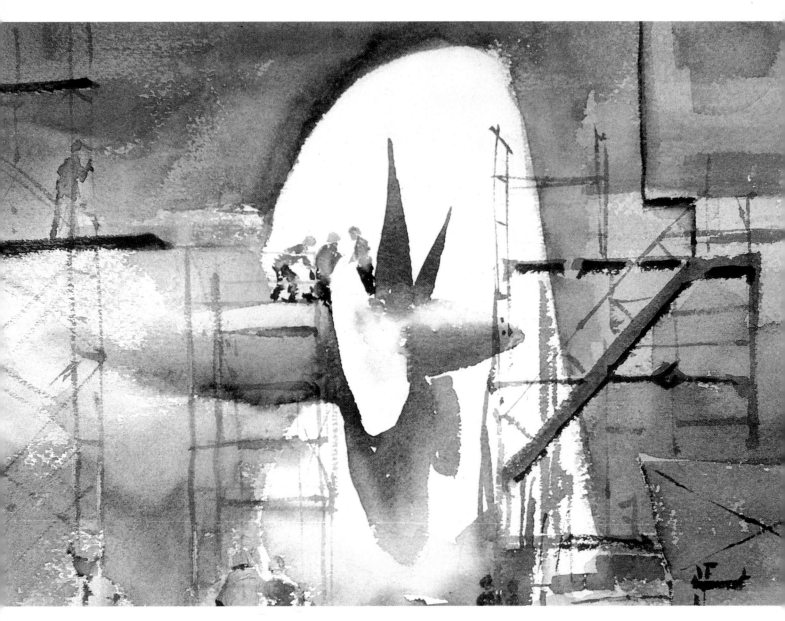

In Drydock (sketch)
10 x 14 inches

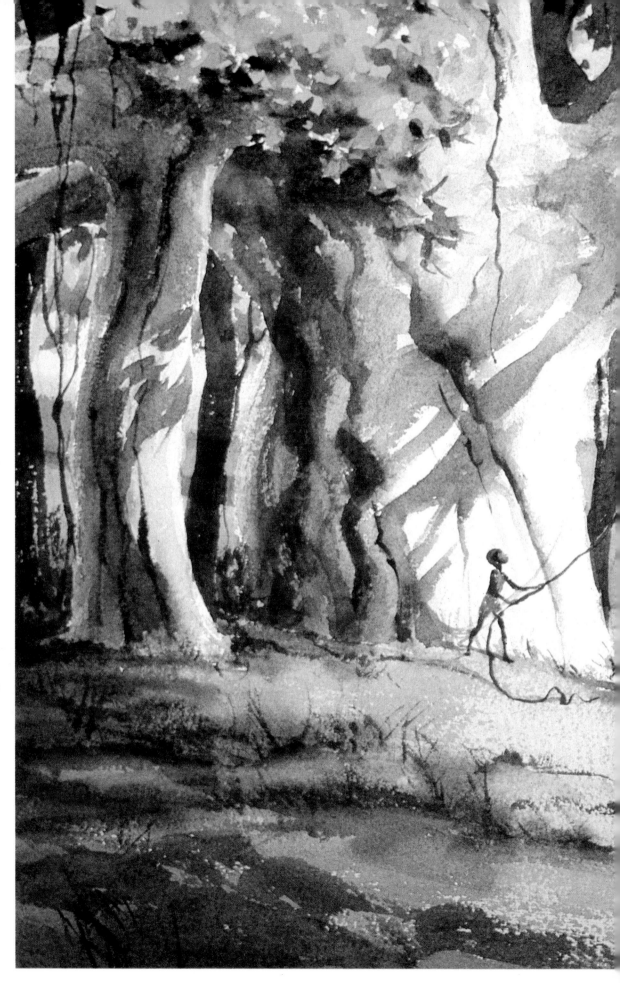

Tarzan
21 x 29 inches

Collection of
Mrs. Dunton Howe

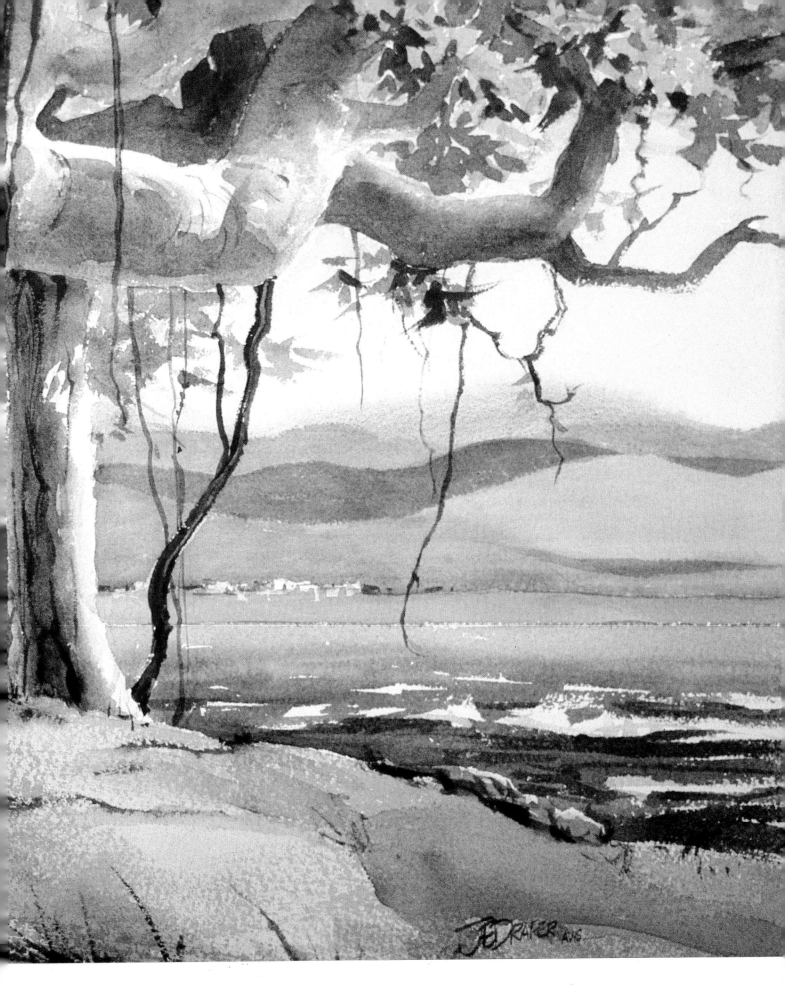

57

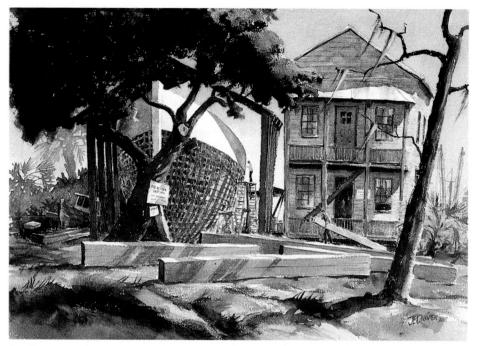

Noah
21 x 29 inches

This old shipyard in St. Augustine has now been modernized and is no longer as paintable. Here again, I added the figure of Noah to help give scale to the boat as well as to add some life to the painting.

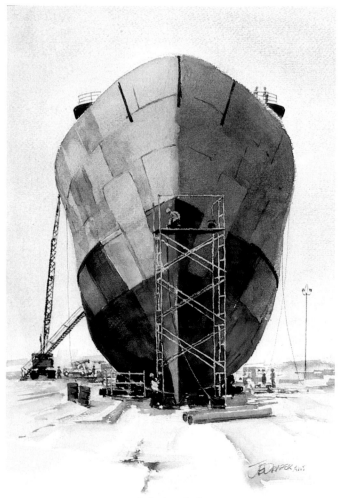

Here, as in *Noah*, including the figures of the men working helped to convey the relative size of the ship. This is one of the space shuttle booster recovery ships under construction.

Shipyard I
21 x 14 inches

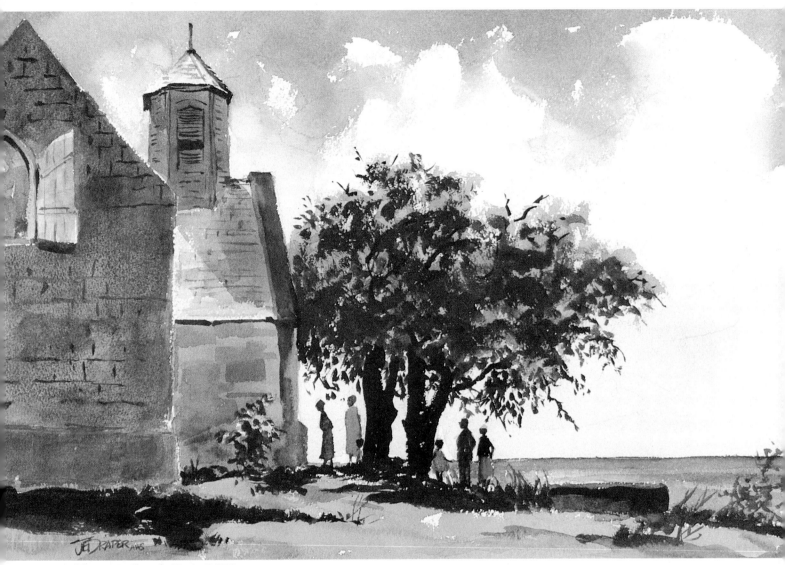

St. Thomas's Church, Nevis, B.W.I.
14 x 21 inches

Adding Human Presence

It isn't often, in my case at least, that a painting done on location under adverse conditions (extreme heat and bright sun) is successful. When it does happen, spontaneity is usually the quality that makes the painting.

The painting above shows the centuries-old St. Thomas's Church on the island of Nevis in the British West Indies. It was one of the painting sites of a workshop that I conducted there. While some of us painted in the broiling sun, other workshop participants stayed in the shade. For my painting, I turned them into parishioners of the church to add some life and human interest to the scene.

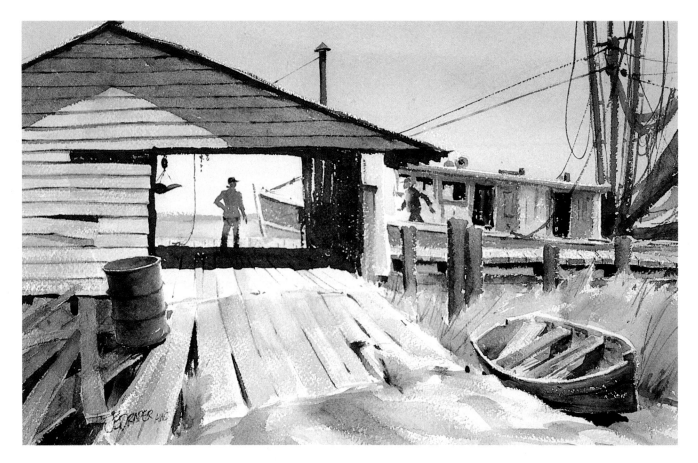

Stirrup Dock
14x21 inches
The strongly shadowed opening gave the painting a good focal point, but adding the figure made it better.

Memory and Imagination

Often when painting on location, I'll find myself working on a scene in which there is no human element. Certainly, there is nothing wrong with this; more landscape compositions are done without figures than with figures. However, I'm not above adding a figure or two from memory or imagination, if I feel such additions will enhance the picture.

Shown at the bottom of page 62 is an example of what I mean. I was painting the overturned dory in Gloucester, Massachusetts, when imagination took over and I added the old sea captain. I think that the painting then took on a storybook quality and probably became more of an illustration with the figure becoming the focal point. Whatever the reason, I liked the result.

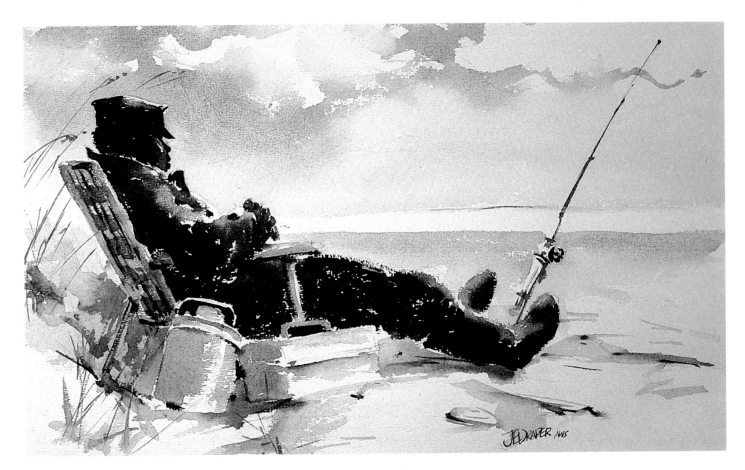

January Day
14 x 21 inches

One cold January morning, my wife and I were walking along the beach at Amelia Island, Florida and we met the gentleman shown here, as he was stamping around in the cold and drinking hot coffee from his thermos. He was getting ready to settle down to a day of fishing. His chair was in place and his rod was setting in its sand-spike. We talked with him briefly, wished him luck and went on our way.

On returning home later in the day, I couldn't get the mental picture of how he was about to spend his day out of my mind. I had to put it on paper while the image was fresh. The painting, intended only as a sketch, was executed in a matter of minutes. It has won several awards.

The lone fisherman on the bridge in the early morning (page 62) was another quick memory sketch. I parked at the other end of the bridge and made a thumbnail sketch. The painting, another "quickie," was done later that day in the studio.

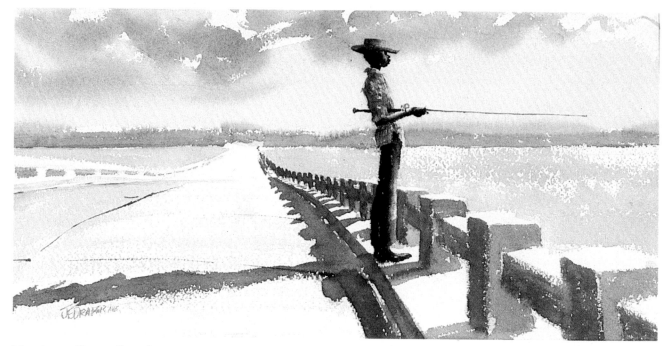

Morning at Nassau Sound
10 x 21 inches

Collection of Doris Wigglesworth

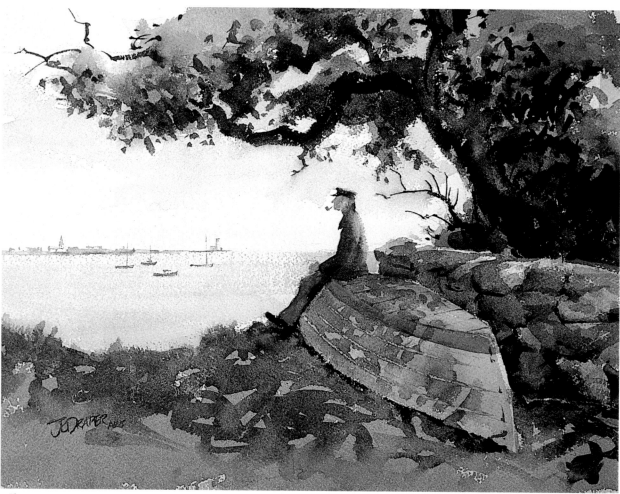

Gloucester
14 x 21 inches

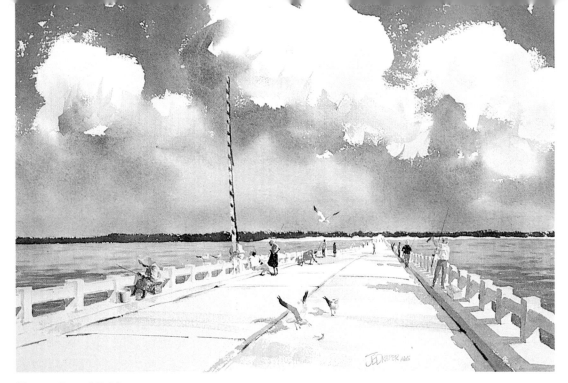

Nassau Sound Bridge
21 x 29 inches

This painting and the one below are examples of interesting space division. In *Nassau Sound Bridge*, the raised striped gate splits the horizon and sky. In *Port St. Joe*, the very high horizon creates an unusual space division.

I like to do fishing-bridge paintings. This long bridge is almost always crowded with people fishing and is a wonderful spot for figure sketching.

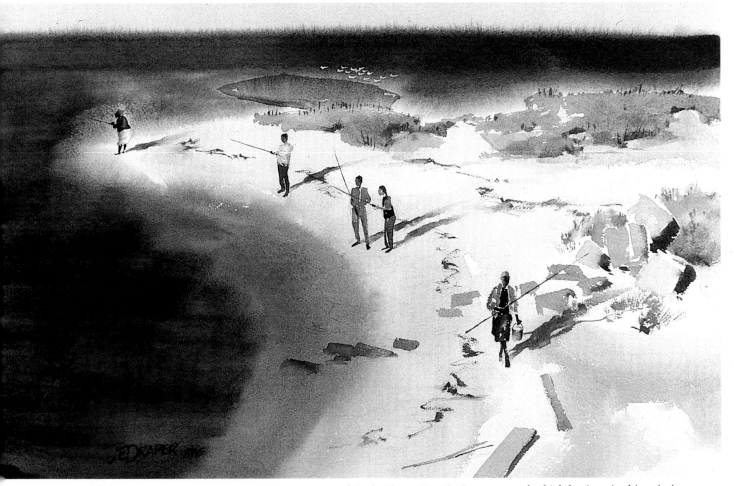

Port St. Joe 14 x 21 inches The high vantage point of the bridge at Port St. Joe gave us the high horizon in this painting.

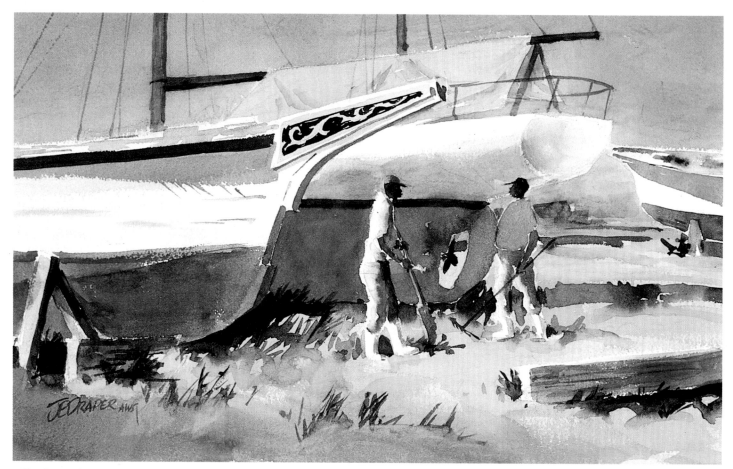

Charleston Marina
14 x 21 inches

A few years ago while doing a demonstration in a Charleston, South Carolina marina, the subject matter was the boat shapes surrounding us. Two of the marina workers wandered by, performed some small task and then left. Once seen, the setting seemed empty without them. So, I added them to the painting from memory.

64

Figure Groups

When including figures in your paintings, you
may be working with groups as often as you will
with single figures. Groups should be considered
as a unit and designed as a unit. Each group
should have an interesting silhouette shape and a
well-designed pattern of light and dark within
this shape. As a whole, it should relate well to
other elements in the painting.

On some occasions, the overall shape or
silhouette of the group will be more important
than the definition of the figures within it. When
definition and separation is required, it is best
achieved by means of value and color, with value
being the most important factor.

Each group should be planned as a
composition in itself, with careful attention paid
to such things as variety of sizes, shapes and
spacing within the outlines of the group. Make
sure that the light and dark pattern within the
unit works satisfactorily before adding color.

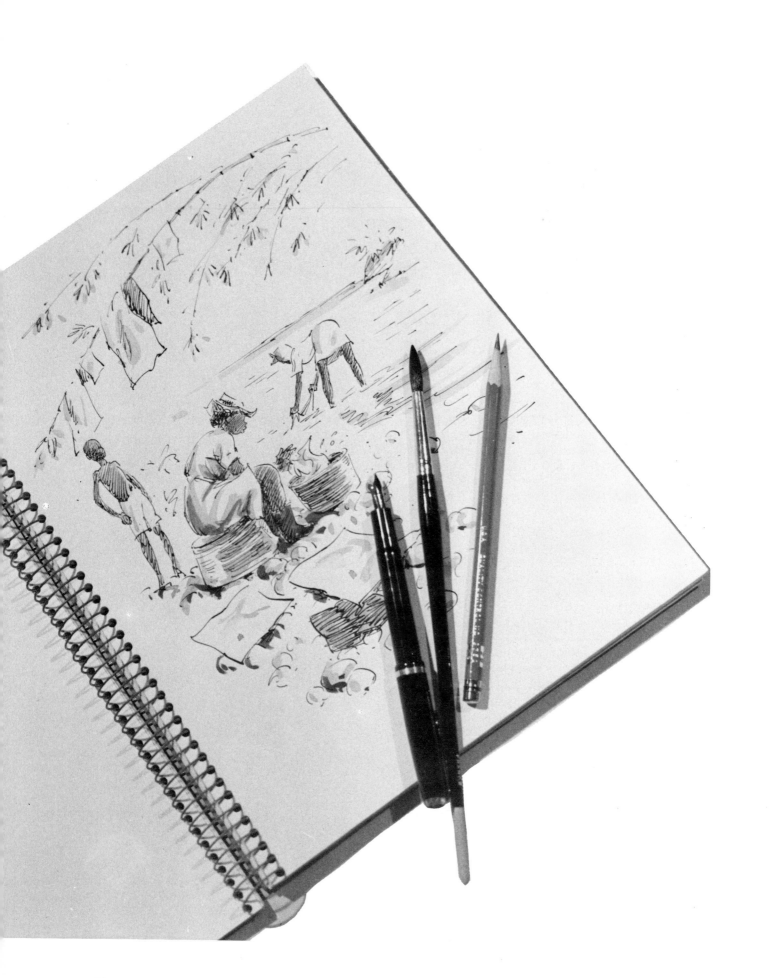

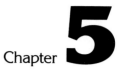

The Sketchbook Habit

In the preceding chapters, I have referred to the sketchbook frequently as a valuable source of figure information for your paintings. In addition to providing data on figures, your sketchbook also can supply details of the settings, as well as colors, mood, etc.

A camera also can be used to collect this kind of data but the quick sketch — jotted down in passing — is likely to retain more of your immediate feelings for the subject (for use at a later date) than a photo can. A hurried gesture drawing of figures on the move, however crude, can be the best means of retaining your original inspiration.

Spontaneity is a highly desirable quality in a watercolor painting. Sketchbook work, done while on the move is bound to look quick and unlabored. This quality, however, is difficult and sometimes impossible to recapture when you are transposing sketch information into your finished painting.

I find that my sketchbook work, especially when I am gathering information for a commissioned painting, may be unbelievably crude. Often it is intelligible only to me, but it is sufficient and all that I need for the purposes at hand. In most cases, having the sketch before me keeps me from losing touch with my original feeling that prompted the sketch.

In other instances, being intrigued with the potential of a subject, I find myself carried away with the possibilities before me. This will sometimes result in the development of a sketch to the point where it becomes a little gem, and has a particular quality of its own that I know cannot be recreated in a follow-up painting.

I simply save these fully-developed sketches in the sketchbook as completed impressions.

A Hong Kong seafood vendor, done in brush and ink plus wash. If you are sketching on foot, brush and ink is a little awkward to carry and use. It is better suited to working over a pencil sketch later.

This drawing of a Mexican street sweeper is an example of drybrush.

Sketchbook vs. Camera

In my sketchbooks, I find myself concentrating on two aspects: the people involved in the scene, and compositional thumbnails. In addition, I will make quick studies of miscellaneous details that are pertinent to the scene. Later in the studio, I find that these sketches do the most to bring back the essence of the scene to me.

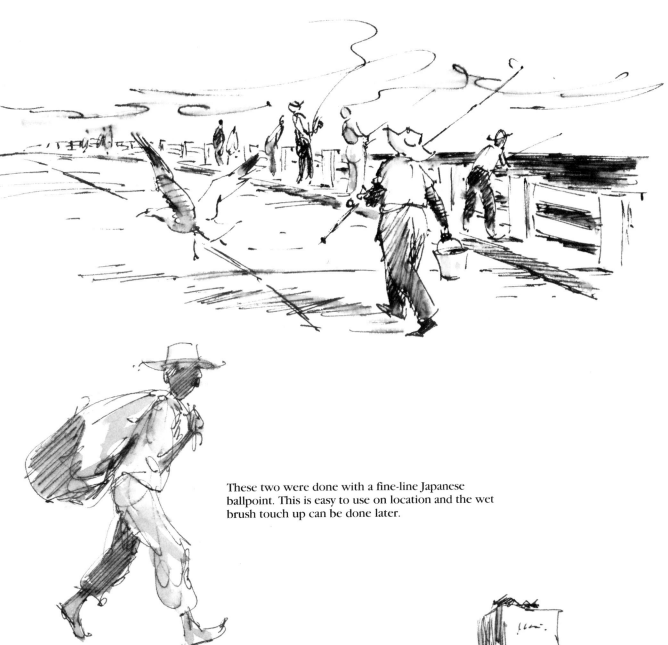

These two were done with a fine-line Japanese ballpoint. This is easy to use on location and the wet brush touch up can be done later.

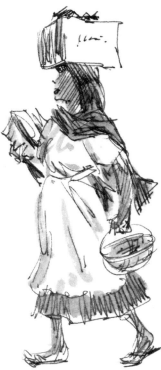

A camera may be used in the field to pinch-hit in collecting figure information in those situations where, for practical considerations, sketching isn't possible. I find that the use of a long lens on the camera gives me the added advantage of being able to work at a distance, without making the subject or subjects conscious of the camera.

Since this is not a book on photography, I will not go into an extended discussion of what camera or cameras to use. There are many good brands on the market, so it is difficult to single out one. The most useful type of camera for me has been the SLR (single-lens reflex) that takes 35-millimeter slides.

I use a 65-135mm zoom lens, which I put on the camera before setting out. The range of this lens is ample for almost any subject and, to a certain extent, allows me to compose with it.

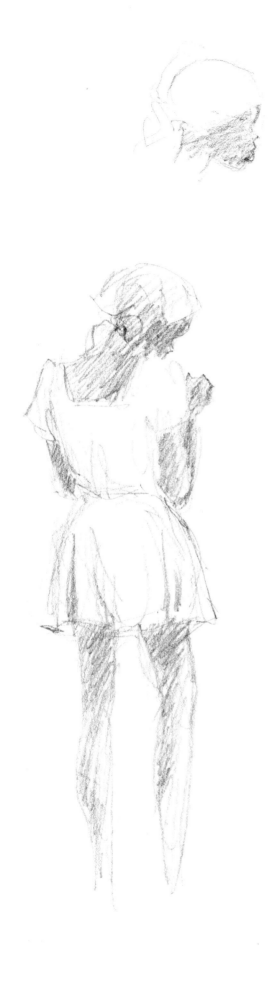

Sketching Equipment

Sketching equipment should be chosen carefully, keeping the element of portability in mind. At the very least, all that is needed is a sketchbook and something with which to draw, but there are other considerations as well.

Initially, you should think in terms of traveling on foot and being ready to sketch at all times, rather than just at such times when you are on a painting trip. This necessitates having a sketchbook that can be conveniently carried in your hand or pocket, plus a few pencils or pens.

The most portable sketchbooks on the market are small, palm-sized books. These are great when you want to work inconspicuously. I prefer, however, to come right out into the open and work on a page size that is at least large enough to support my hand as I work. For me, a 5½ x 8½-inch book is the minimum size.

My favorite is the 9 x 12-inch "Aquabee Super Deluxe," which is spiral-bound. I also use a hardbound 8½ x 11-inch book by Strathmore.

One of the most important considerations in the choice of a sketchbook is the quality of the paper. You want to make sure that it responds well to whatever drawing instrument you are using. In addition, the paper should be heavy enough not to have too much show-through, so it will stay reasonably flat when using watercolor.

Deciding what pencils and pens to use is next. The common, everyday lead pencil is a wonderfully sensitive tool, and it is the one that I am most comfortable working with. For sketchbook work, however, there are some drawbacks.

The ordinary lead pencil tends to smear, and the more your sketchbook is handled, the more messy it becomes. It also has the tendency to offset onto the facing page. As the sketch smears, it also lightens. Occasionally, a lightly-drawn sketch will almost disappear. Of course, a sketch of this type does have the advantage of being erasable, so you are not committed forever to the first line that you put down on the page.

When reworking sketches at the end of the day, I usually reinforce pencil lines with ink and remove any heavy lead pencil lines with a kneaded eraser. I may also use watercolor to drop in a little color or tone.

These quick studies were done with a 2-B pencil. It's a favorite sketching tool of mine because of its easy responsiveness, and it is certainly the most convenient. However, pencil will smudge; and in the sketchbook, the drawing will lighten because of the offsetting on the facing page.

These soft-pencil sketches depict tourists in St. Augustine, Florida. They were made less quickly than the studies above, and they contain more detail.

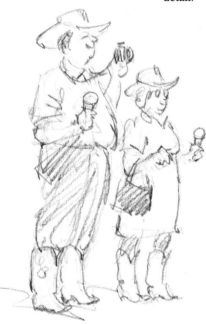

The sketch fountain pen caught these new mail-boat arrivals on Monhegan Island.

While sketching in the field, you may want to make notes on the sketch of any particular colors observed, especially when the color is important for reasons of authenticity or unusual color interest.

I have found Prismacolor to be a good, non-smearing pencil. These colored pencils can be bought either singly or in sets. While I seldom do a colored pencil drawing, I find their black and warm gray dark to be good sketching tools.

The Prismacolor pencil marks are not erasable but can be handled with a very light touch, in order to feel your way into a drawing.

In my opinion, Wolff's carbon pencils are also good. They have a distinctive line quality and require a slight tooth to the paper for best results. They can be deliberately smudged to achieve shading effects, but will also smear on their own. This smearing can be overcome by means of a fixative spray, but this is an extra operation and something else to carry along.

Pens are possibly the best tools for use in the sketchbook. There are flexible-nibbed pens, ball-point pens, and technical pens. The latter have become fairly popular for tightly-rendered, black-and-white drawings, but I prefer the more expressive line possible with a flexible point.

Both the Pelikan and the Koh-I-Noor sketch fountain pens are good, and both offer a wide range of nibs. As a direct medium, the pen line is positive and there to stay. This direct quality is most desirable and should be cultivated as much as possible.

In your sketchbook, be bold and direct. Don't worry about incorrect lines. Draw over them until they look right. Remember you are producing a sketch, not finished art.

The sketchbook habit develops the habit of drawing. Keep the sketchbook with you as much as possible and draw, draw, draw. Your sketchbooks will become valuable sources of information, inspiration and ideas, and the habit will do wonders for your draughtsmanship.

A subject, holding as still as this, made possible a more studied pen sketch.

India ink and brush.

This one is drybrush.

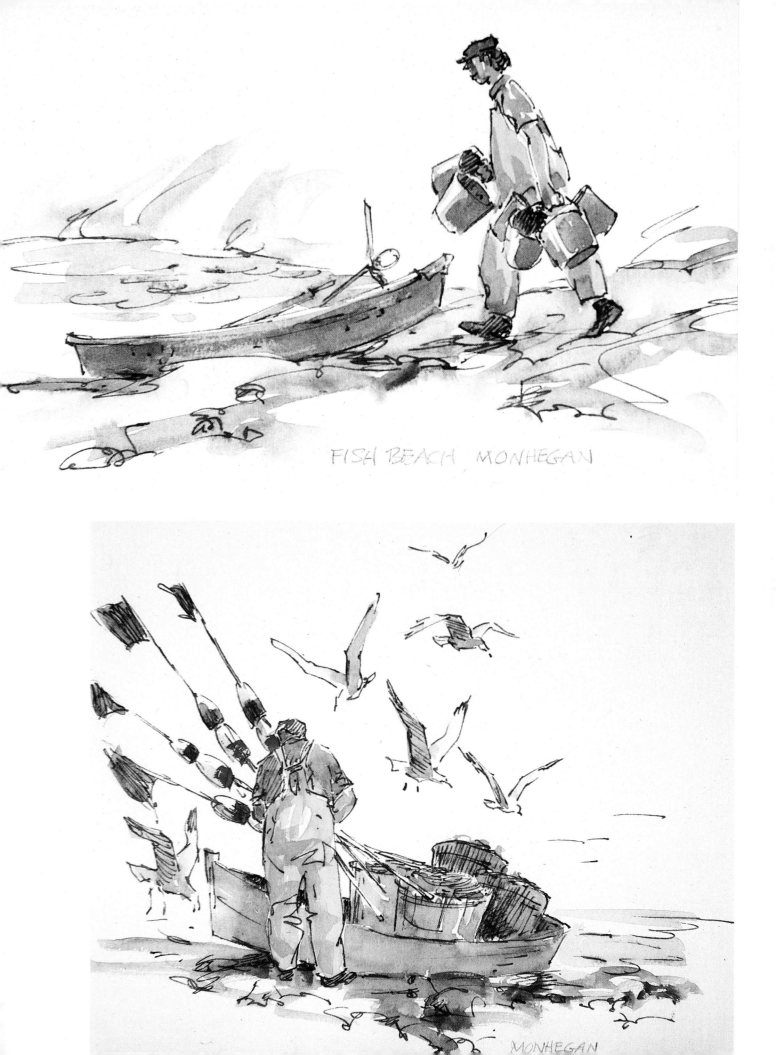

FISH BEACH, MONHEGAN

MONHEGAN

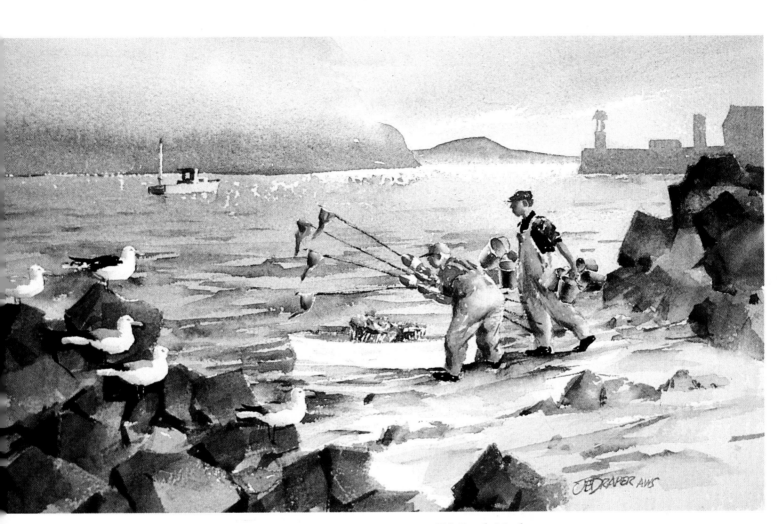

A.M. at Fish Beach, Monhegan
14 x 21 inches

An example of how sketchbook information can finally result in a finished painting. The sketchbook figures of the men loading gear, shown on page 74, were done on the spot. The early-morning fog and the gull audience were painted from memory. I relied on the camera for the background landscape details.

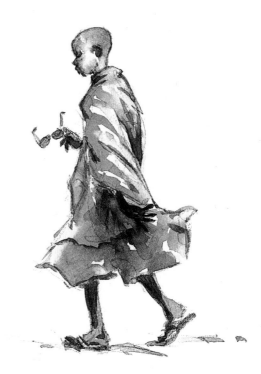

This sketch was done with pencil and watercolor wash.

A studio painting of monks at the Grand Palace, made from reference sketches.

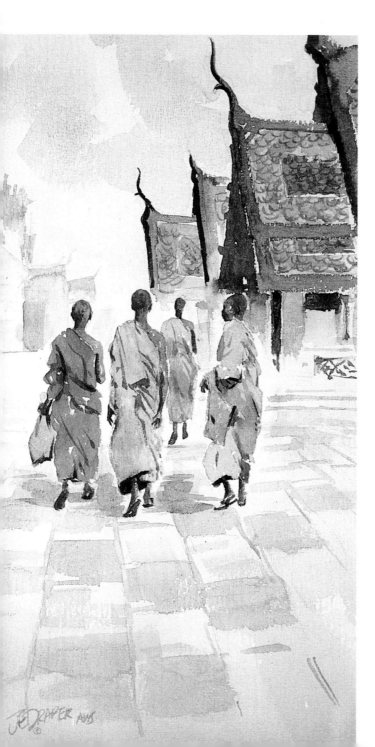

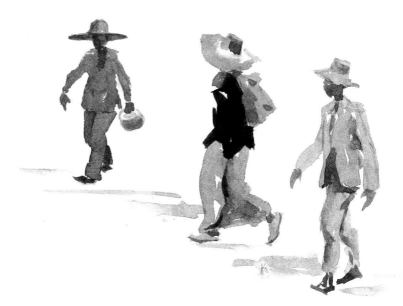

Quick watercolor sketches of Bangkok street folk.

A nylon-tipped pen was the tool for these figures. The lower two figures appear in *Street Sweepers, Kyoto*. Notice the small changes I made to fit them into the painting.

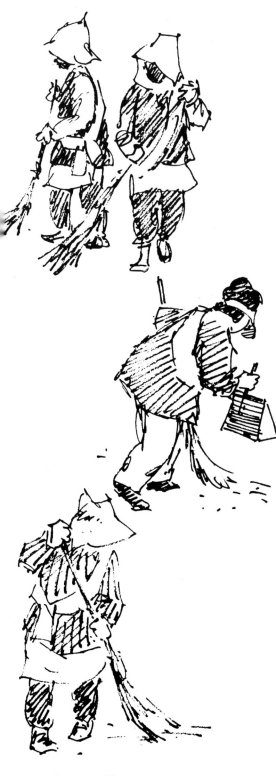

Street Sweepers, Kyoto
28 x 11½ inches
These ladies are the reason Kyoto's streets are so clean. In the early morning, they were there to be sketched, and I planned several compositions around them. The street pattern seen from our hotel window provided the setting for this one.

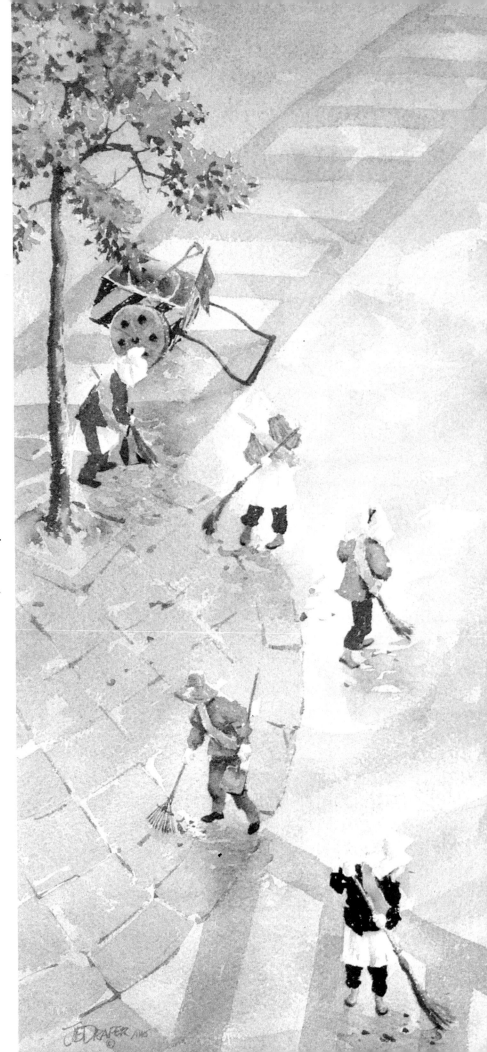

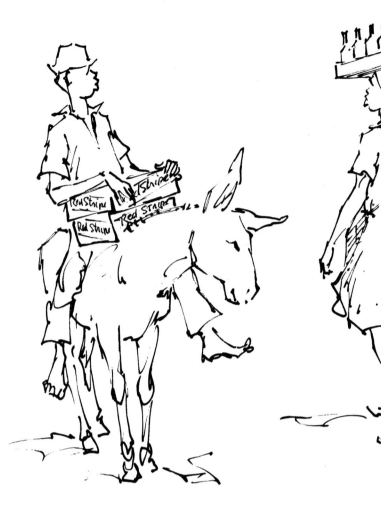

The sketch fountain pen is used again for these
Jamaicans carrying Red Stripe beer and orange soda.
Below and right are pencil. The children are at Miss
Jolly's kindergarten.

Berle Valentine, poling our raft down the Rio Grande in Jamaica, as seen from our passenger seat on the stern. A gray marker and a nylon-tipped pen were used for these sketches, plus a little watercolor dropped in later on the larger sketch to the right. It seemed natural to exaggerate his action a little.

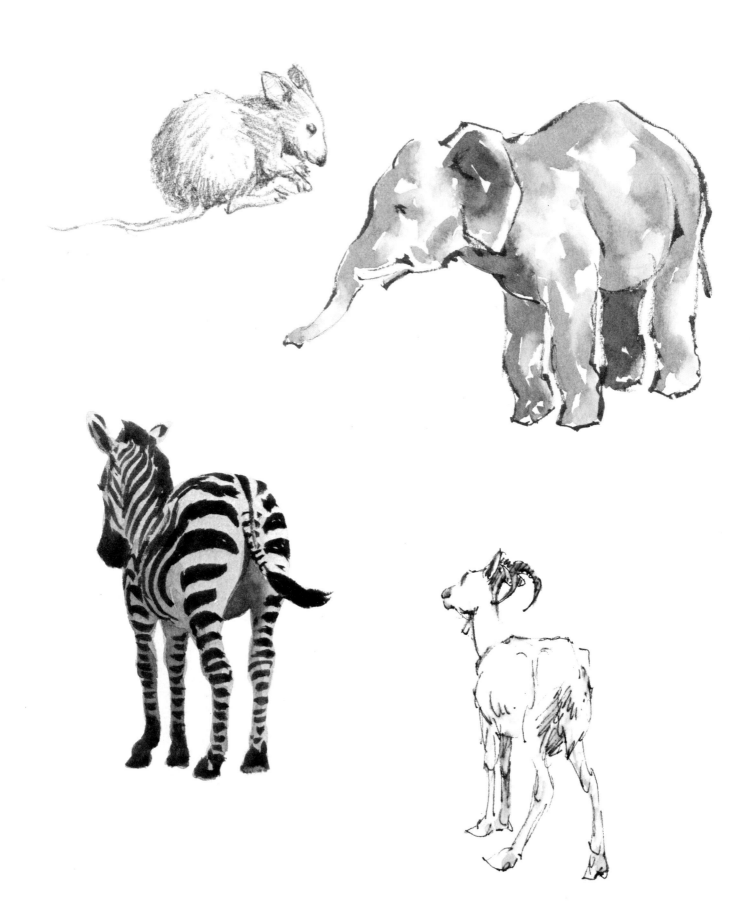

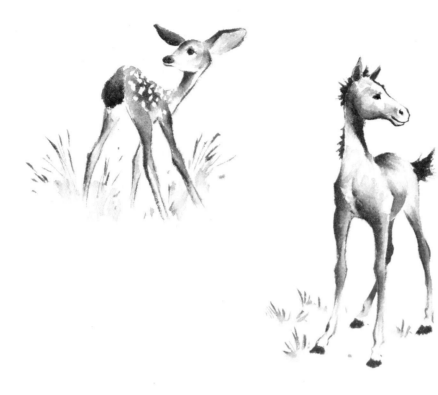

Other Than Human

So far, we have studied the figure for the purpose of adding the element of life to our compositions. We tend to think of this element of life as always being human.

Animals, however, have just as much to offer a painting as people. A cow, a dog or even a stray elephant can — under appropriate conditions — add as much to your painting as a human being.

I get much pleasure from sketching animals. I find that many of them are not without personality and can be just as interesting to interpret as people.

Humans, of course, are mammals, as are most of the animals with which we are familiar and come into contact on a regular basis. Physically, most mammals (including humans) have much in common. The skeletons of all mammals, while varying greatly in proportion and conformation, coincide to a remarkable extent on a bone-for-bone basis.

The elephant, for instance, has humerus, radius and ulna bones in his foreleg, just as we do in our arm. Comparable similarities exist in all animals no matter how large or small they may be. The differences in proportions have to do with an animal's way of life in his particular environment.

We have fingers and hands, while another animal may have hooves. Many other adaptations to the environment occur. The whale's arm and hand become a flipper, but with most of the same bones found in human beings.

A study of comparative anatomy such as this could go on for great length. For our immediate purpose, however, it is only necessary to know that such similarities do exist and that your drawings reflect an awareness of them.

I often take my watercolor classes to the zoo for a real sketching workout. Sketching animals as they move about takes both practice and patience. As the animal moves around, it is often a matter of first roughing in a pose, and then developing it in bits and pieces as certain parts of the pose reoccur.

It is best to stick with one animal until you develop enough familiarity with its form to be able to make quick gesture sketches that will capture its moves, proportions and identity. Once you have achieved this, it becomes much easier to make more studied sketches, even if the animal is always on the move.

Sketching animals is one of the best ways I know of to improve your ability to observe and draw.

Notice the bone-for-bone similarity between the human arm and the elephant's foreleg.

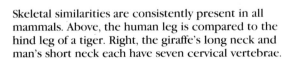

Skeletal similarities are consistently present in all mammals. Above, the human leg is compared to the hind leg of a tiger. Right, the giraffe's long neck and man's short neck each have seven cervical vertebrae.

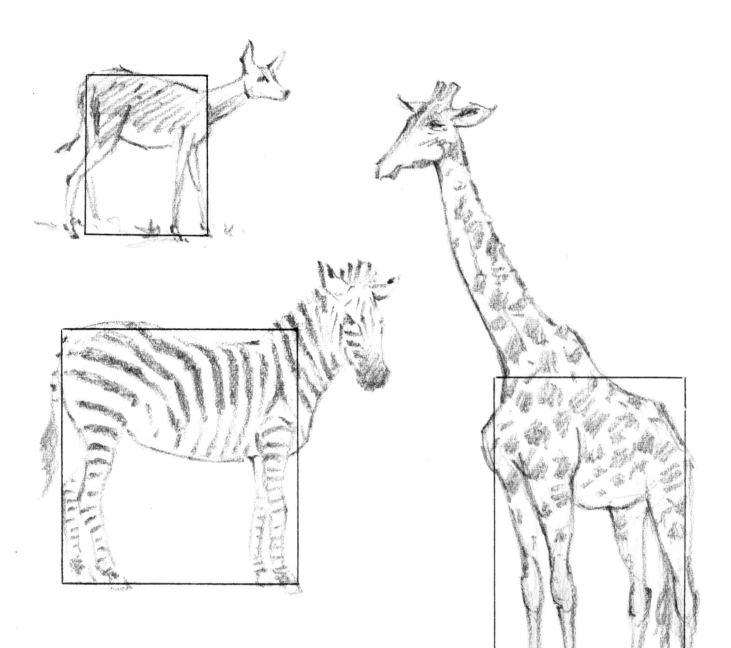

On location at the zoo or anywhere, learn to take a quick reading of the animal's general proportions before you start to draw. Visualizing proportions by fitting the length of its body and the height of its back into a rectangle or square can help.

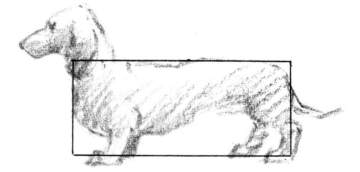

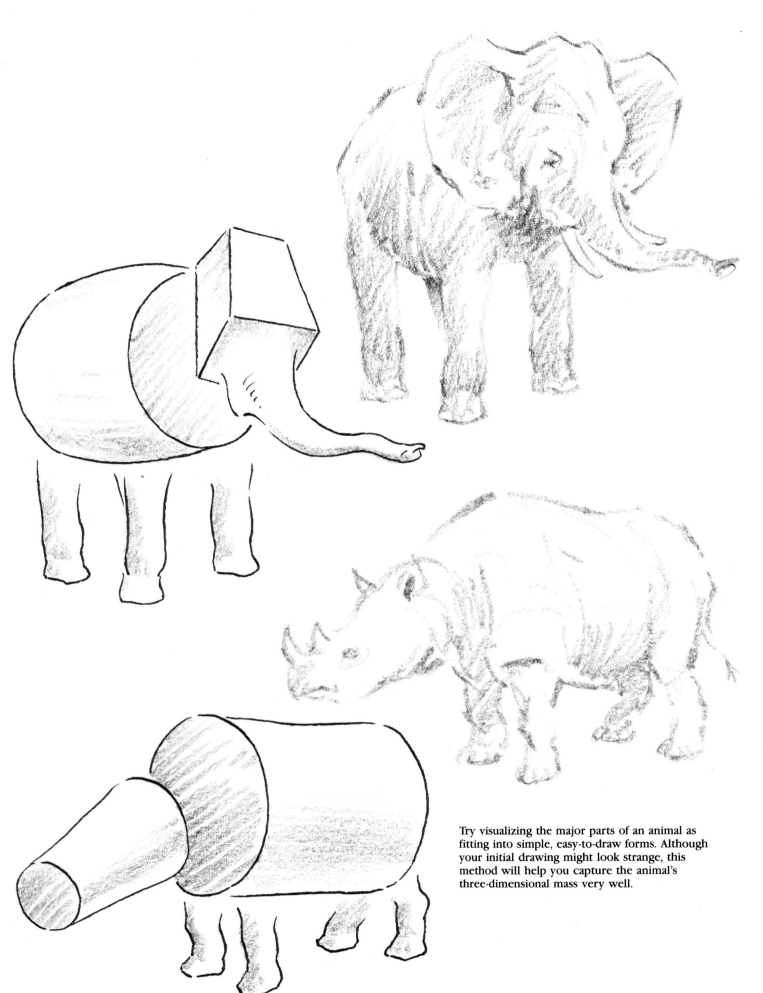

Try visualizing the major parts of an animal as fitting into simple, easy-to-draw forms. Although your initial drawing might look strange, this method will help you capture the animal's three-dimensional mass very well.

It is best not to burden yourself with paraphernalia. A pocketful of sharpened 6B pencils and a fairly large sketch pad will get you through a day at the zoo. Nap time provides an opportunity to study a still animal and capture much detail.

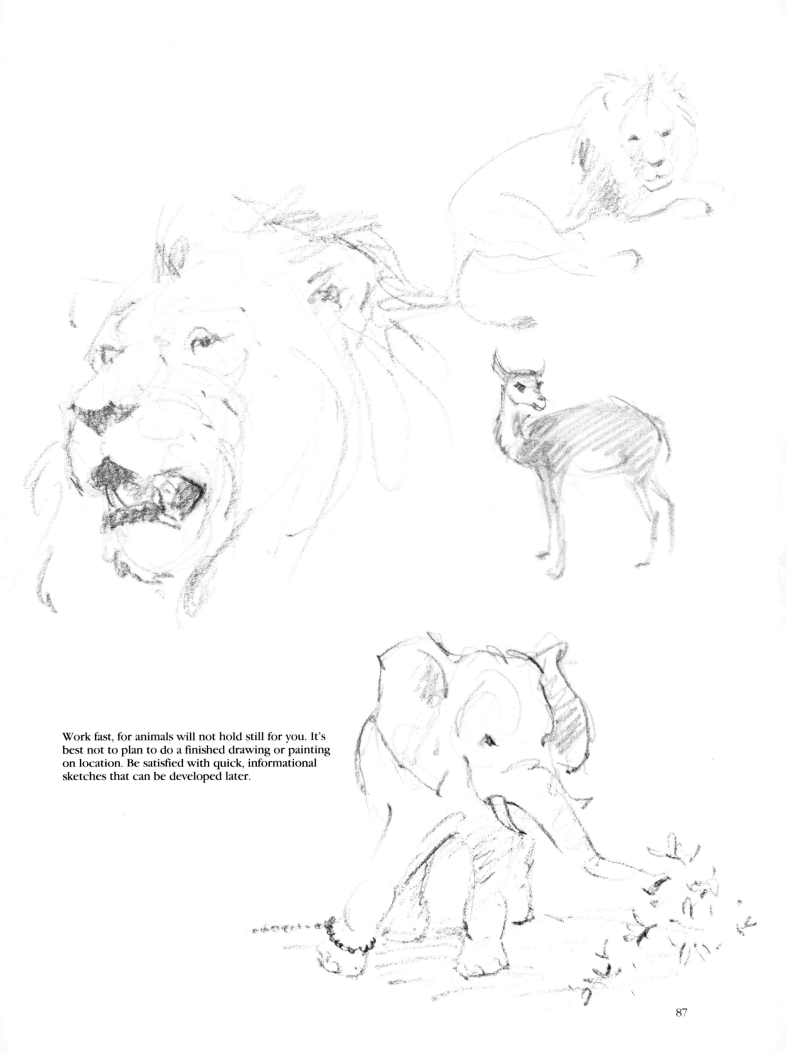

Work fast, for animals will not hold still for you. It's best not to plan to do a finished drawing or painting on location. Be satisfied with quick, informational sketches that can be developed later.

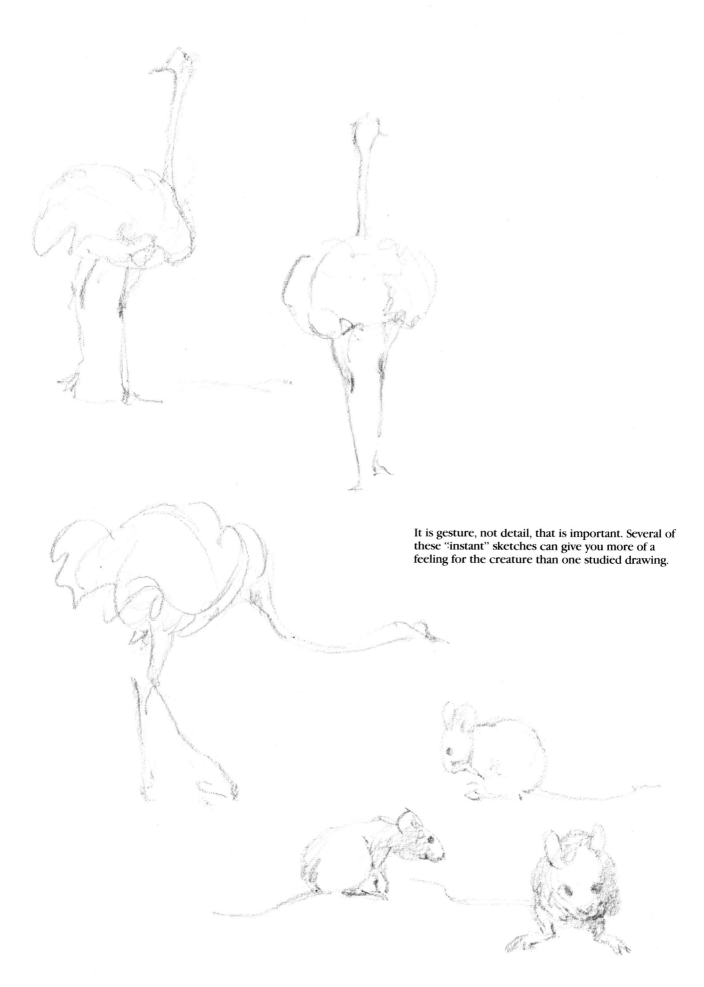

It is gesture, not detail, that is important. Several of these "instant" sketches can give you more of a feeling for the creature than one studied drawing.

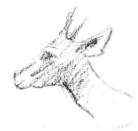
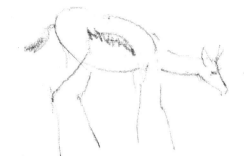
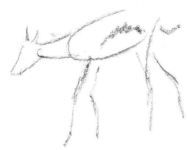

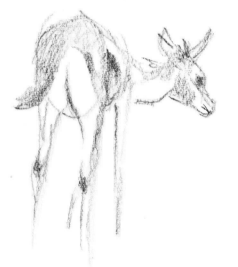
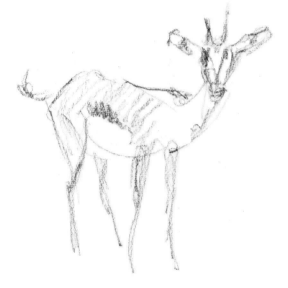

Sometimes it is advisable to spend a lot of time concentrating on one animal, making many quick gesture sketches. This eventually enables you to capture its identity and movements with a minimum of strokes.

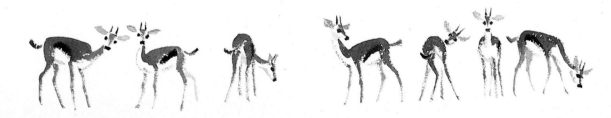

Occasionally, if you plan to settle down and study just one animal, you might try watercolor. Here again, quick brush gesture sketches, with just one or two colors, usually give the most satisfying results. The Thompson's gazelle sketches were done this way, with burnt sienna and black.

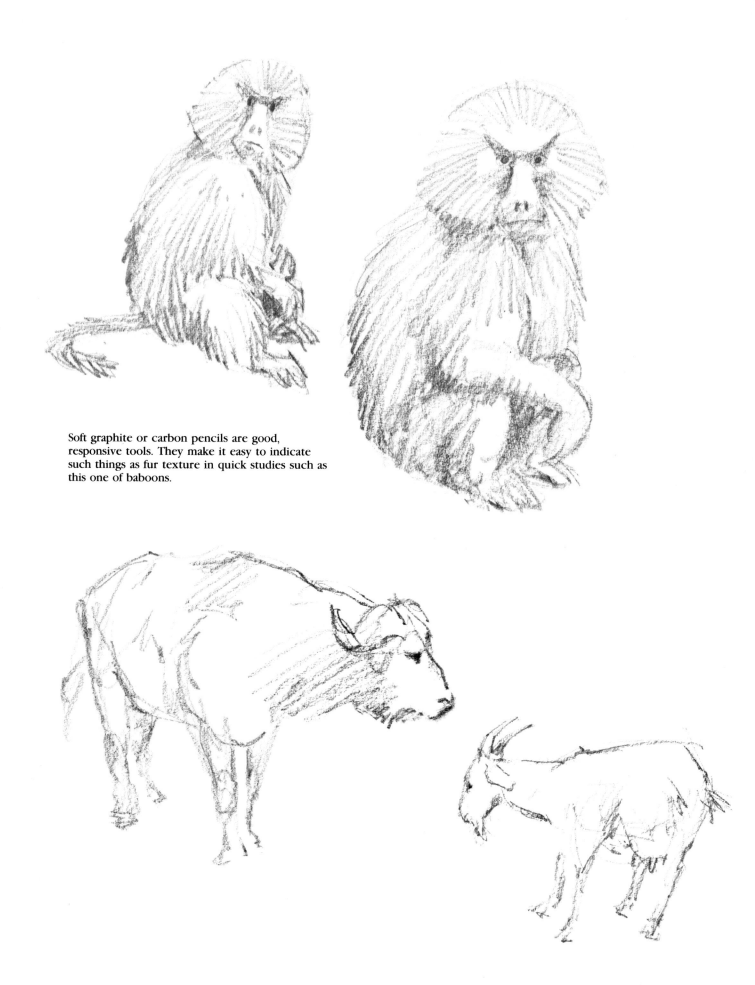

Soft graphite or carbon pencils are good,
responsive tools. They make it easy to indicate
such things as fur texture in quick studies such as
this one of baboons.

No chance of these gibbons posing for you. Their thing is nonstop acrobatics, especially if someone is watching. However, they are a made-to-order subject for gesture sketching, and lend themselves to impressionistic studies such as this.

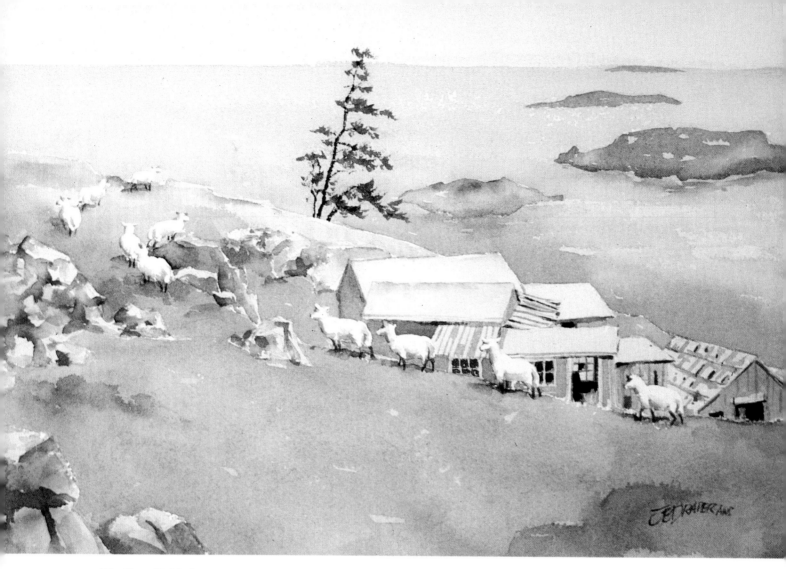

The Hermit's Flock
10 x 14 inches

The hermit Capt. Raymond Philips lived on Manana
Island, across from Monhegan Island, in this
complex of added-on shacks. His sheep continued
to graze on the island after his death.

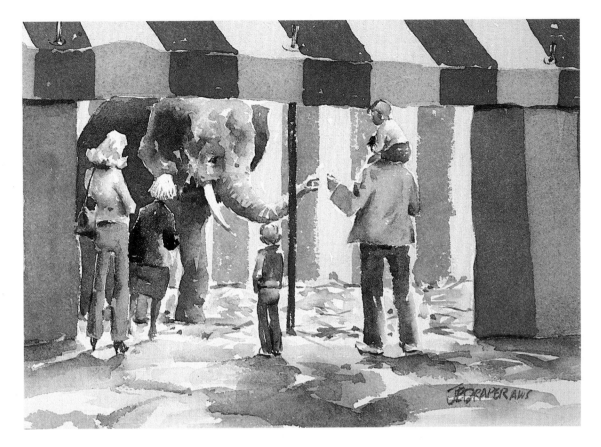

The Circus Grounds at Pau, France
7 x 9½ inches

Back lighting provided by the lighted interior of
the tent creates an interesting feeling in this small
study.

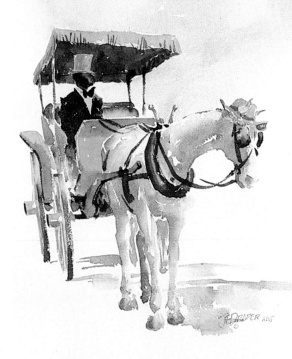

St. Augustine Buggy
14 x 10 inches

This is just a lighthearted caricature sketch. The quick execution is consistent with this feeling.

St. Augustine Buggy Drivers
10 x 14 inches

The carriages and their drivers waiting for St. Augustine tourists always furnish good subject matter. Here the wet street reflections add interest.

The Oaks at St. Simons'
21 x 29 inches

This illustrates how the presence of something alive, however small, can add to a painting. The bunny was hopping around and nibbling at the greenery all the while I was painting. The painting wouldn't have been complete without him.

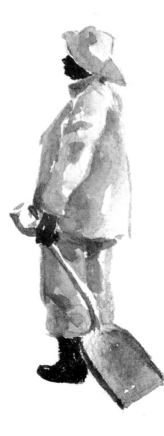

Chapter **7**

Demonstrations

Demonstration 1

The "Patricia M"

These shrimp boats work up and down the
Florida east coast, remaining fairly close to
land. Occasionally, one will lose power or
have some other problem and end up on the beach.
The *Patricia M* was one of these. She came ashore
on a resort beach and attracted an audience of
beach-walkers and swimmers, as well as becoming
the subject of many of my sketches and several
paintings. This demonstration was developed
from my memory of the scene.

The Drawing:

Any subject as complicated as this requires a
considerable amount of work in the drawing
stage. For this reason the drawing is done on a
large tracing pad. There will be many trial and
error changes along the way, and working on the
tracing pad will save the wear and tear of erasures
on the watercolor paper.

The placement and sizes of the figures was
determined by using the method described in
Chapter IV. When using this perspective method,
it is only necessary to establish three or four key
figures, and then, using these as a guide, the
others can be easily placed and sized by eye.

When I was finally satisfied with the drawing, I
blackened the back of the tracing paper with a
stick of graphite and transferred it to the water-
color paper. I was now ready to start painting.

Stage I:

Since the background of the sky and ocean will
be painted very freely, using big brushes, I
decide to mask some of the detail. I like to keep
masking to a minimum, but the masthead and
crosstree, as well as the bow of the boat with the
standing figure will be hard to work around
while painting rapidly with a 1½-inch brush.

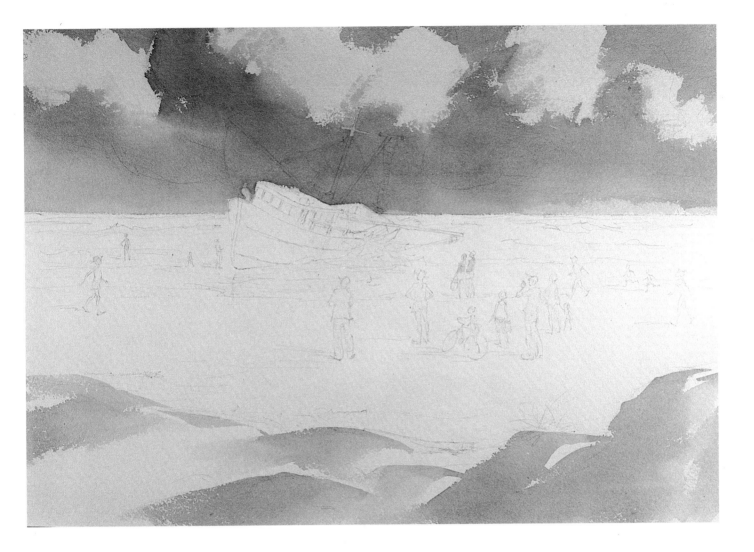

The ocean will also be painted freely with a #10 round brush, so I mask any parts of figures that have the ocean as a background. I use Winsor & Newton's Art Masking Fluid.

This particular sky, to be successful, must be painted in three fast stages, with the final stage being done before the first stage dries.

The first stage is a band of yellow ochre plus a touch of cobalt blue along the horizon. This is followed by a gray made of approximately equal parts of ultramarine blue and burnt sienna. This gray is used to form the shadow and undersides of the cloud masses.

Next I use Winsor blue for the blue sky, defining the tops of the cloud shapes, and then quickly with a very light touch I pull the Winsor blue down through the two, still wet, previous stages.

For the foreground sand I use a mixture of yellow ochre neutralized with a small amount of violet. This whole first stage, sky and foreground, is painted with the 1½-inch flat brush.

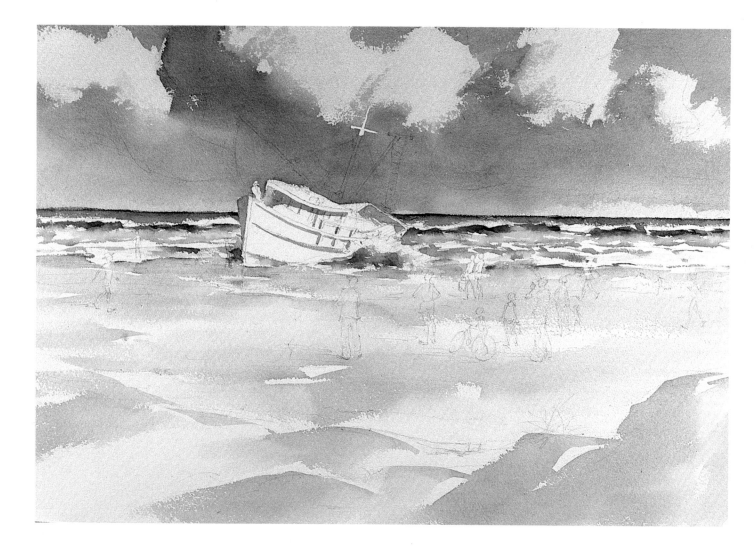

Stage II:

The sky is now dry enough for me to paint the ocean, starting with the horizon. The color along the horizon is cerulean blue with a little Winsor green and a touch of Payne's gray. After painting the horizon, I bring the ocean forward toward the beach, allowing the roughness of the paper to give me the foamy edges of the surf. Adding yellow ochre to the mixture gives a yellower green to suggest the shallower water. Toward the edge of the beach I allow quite a bit of white paper to show, representing the foam.

As soon as the ocean was dry I removed all the masking and turned my attention to the shrimp boat. With a wash of cobalt blue, plus a touch of burnt sienna, I put in the shadow pattern indicating the form of the hull and cabin.

At this point I felt that I had provided a setting for the figure interest to come.

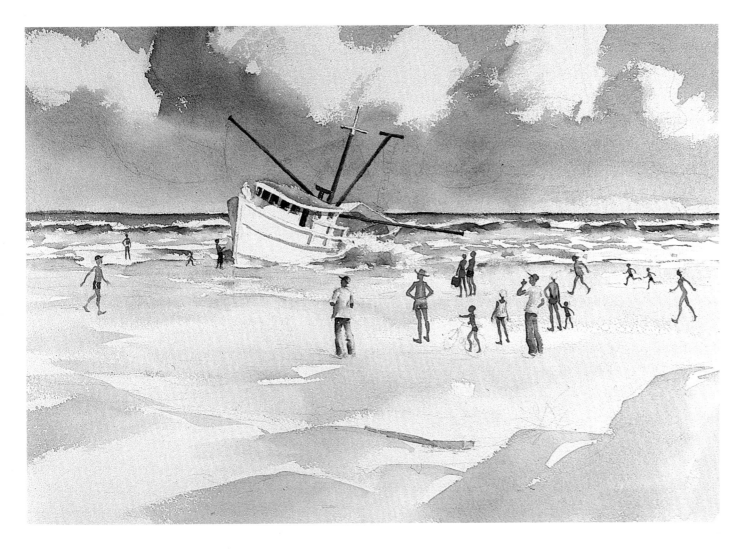

Stage III:

All the broad, big-brush painting is behind us, and with it most of the chances of things going wrong. The sky, in particular, wouldn't lend itself to any correction, and if it hadn't turned out I undoubtedly would have started over.

From here on I will deal mostly with detail, while consciously trying for a feeling of looseness.

In working on a very busy scene such as this, it is better not to concentrate on completely finishing the detail of any one area at an early stage, since this will commit you to the same degree of finish for the entire painting. Often, you will find that the painting has somehow finished itself at a certain point, with less detailing than you might have originally planned and as a result the painting is better for it. It's the old story of knowing when to stop.

Taking the detail in stages, I begin by putting in the more important elements of the boat's rigging and some features of the hull and cabin. This means painting in the mast and booms, the deck and the cabin windows and door.

I now turn to the figures, taking them one by one, blocking in the flesh tones and the clothing colors. So the flesh tones will be dark enough to give each figure a good silhouette value, cadmium red plus a lesser amount of yellow ochre is used with a touch of cobalt blue. This gives a fairly good suntan color which I allowed to vary from figure to figure.

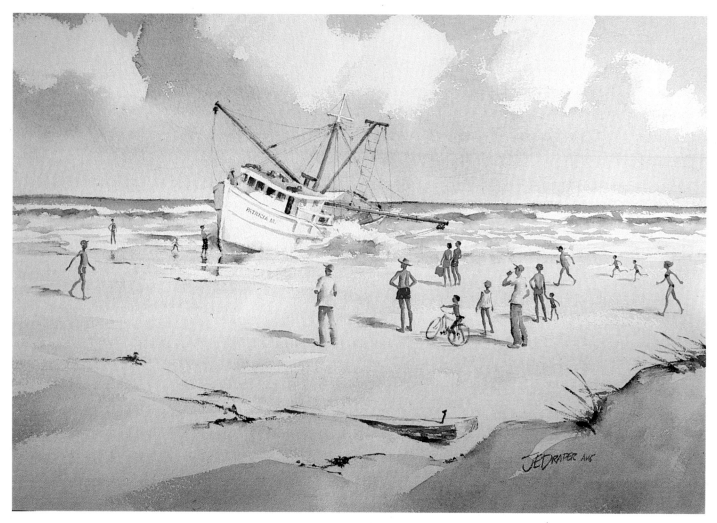

Stage IV:

The center of interest is the shrimp boat with the captain standing in the bow. I paint the captain in, with his yellow foul-weather gear, and then add the green paint to the hull bottom and strengthen various other darks in this immediate area.

The figures on the beach have been painted with a fairly flat flesh tone. I now add some modeling and strength with a darker mixture of the same color. I do the same with the various clothing colors and add shoes, hats and any other detail, including the bikes, as I go.

Ultramarine blue plus a little burnt sienna and alizarin adds a cast shadow to each figure. The shadows serve the dual purpose of attaching the figures to the ground and also tend to point toward the center of interest.

With a small brush I complete the boat's rigging and letter in "Patricia M." on the bow. All that is left is to add some foreground interest by means of the piece of timber, some grasses and the scattered bits of seaweed.

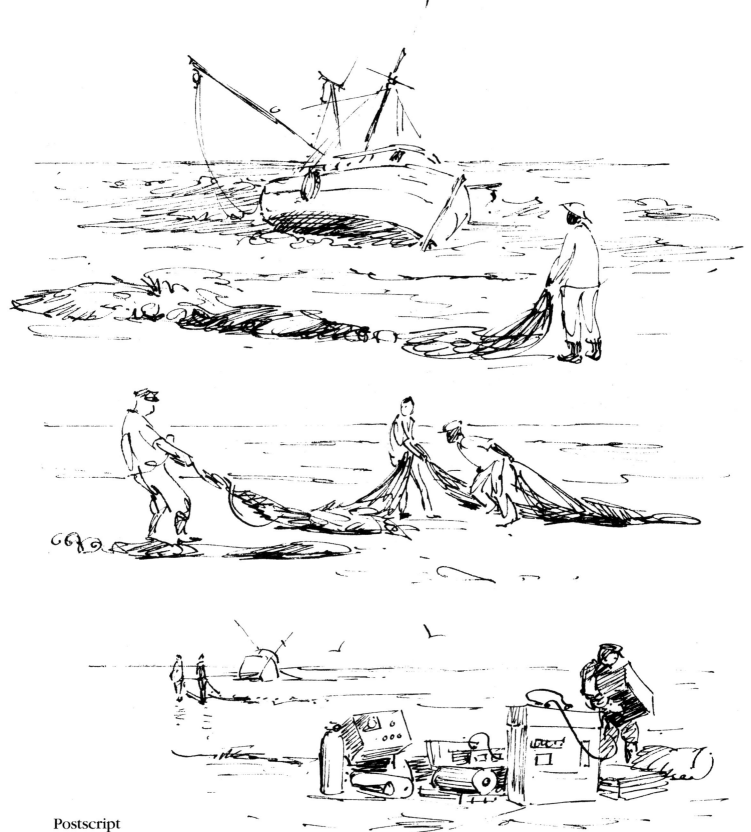

Postscript

They were never able to move the hapless
shrimp boat out to deep water again. After all her
gear and equipment were salvaged, she was left
to break up.

Here are a few sketches of the final hours of
the *Patricia M.*

Demonstration 2

Oaxaca Market

Of several thumbnail sketches, this one was selected to show design and composition for this demonstration.

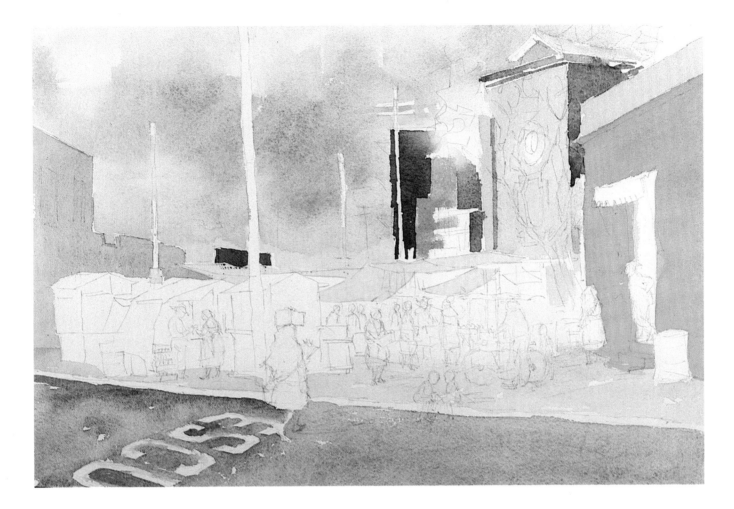

Stage I:

After completing the pencil drawing, I decided that the white shapes of the overhead tent flaps should be saved. I covered them with masking tape before I started painting. Since their shapes are simple and consist of mostly straight lines, the tape was simpler than using a brushed-on masking medium.

Several areas lend themselves to broad washes of color, so I added those next. This establishes the basic color and value of the buildings, sky, and street.

The street is complicated by the white lettering on it, but painting around the letters posed no real problem. It was a sunny-day scene, so I used warm colors on the sidewalk, the street and on the building at the right. I continued by putting in some of the background details of the buildings and the many utility poles.

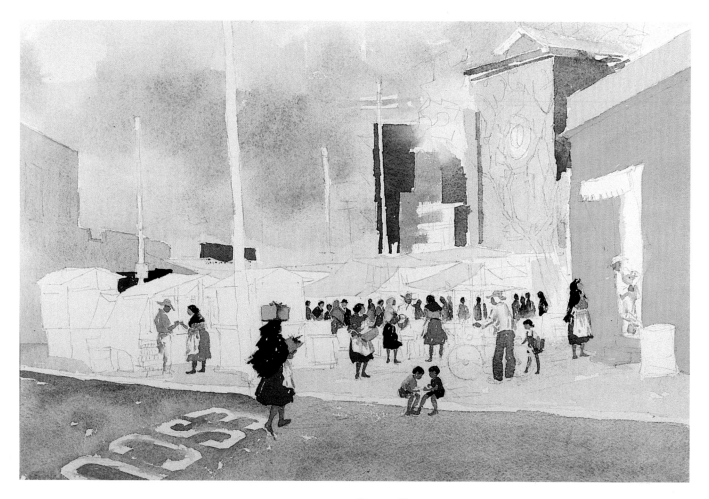

Stage II:

In the "Patricia M." demonstration described earlier, I painted a background tone right across the penciled-in figures, and then painted the figures on top of this tone. Here, we have a different situation because the background is broken up with darks and small color areas instead of a simple, broad wash.

One solution would be to mask the figures. Instead, I chose to paint the figures in, and then, since the background consists of small, easily controlled areas of color, paint around them. Another approach would have been to leave negative shapes for the figures. However, I find it more difficult to control the character of the figure this way, and the results often are not to my liking.

I don't completely finish the figures at this stage, but I am careful to completely establish figure shape. This included the two boys on the curb, even though they have a light background.

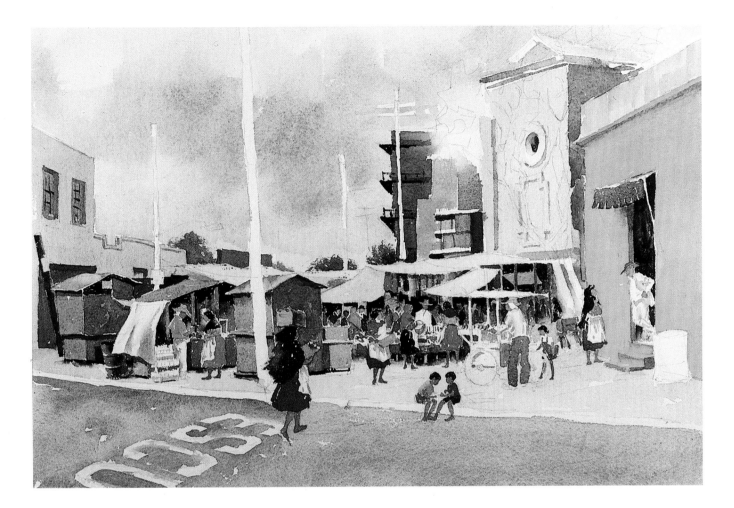

Stage III:

The utility poles were dark on the actual scene, but I felt that they would stand out too strongly in the finished painting. I cut around them when painting the sky, allowing me the opportunity to later paint them light or dark, as I chose.

Next I began to work on the background behind the figures. First, I spotted in the few bright and light colors on the merchandise tables, and then filled in with the darker values behind the figures.

None of this detail, including the figures, is being finished at this point. In the final stage, I will add stronger accents and sharpen detail as needed.

The booths were painted a harsh, bright blue, which seemed to be the theme color for the whole market. I put these just as they were. I also added the windows and balconies to the buildings to provide some additional dark accents.

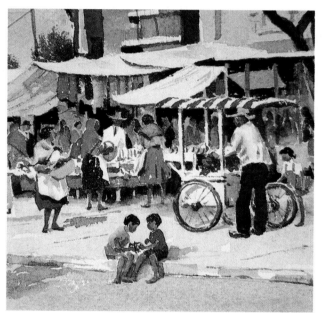

The figure shapes had been established in Stage II;
in Stage IV, details of the scene were clarified and
colors refined.

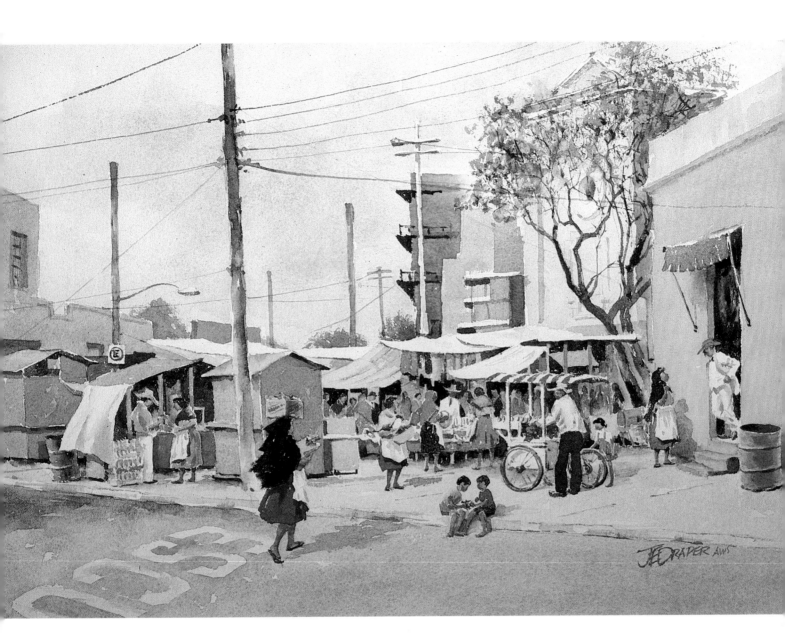

Stage IV:

At this point, the essence of the scene has been established, but a lot remains to be done.

I carefully go over the figures, one by one, sharpening detail, adding darks and brightening a few colors. The shawl of the woman in the center (carrying the basket) is made a light value. The ice cream cart has been detailed and red stripes were added to the top.

The utility poles and wires, which add a certain texture and capture the spirit of a purposely busy scene, were put in. When the poles are painted, I control the values from light to dark, as needed. The tree, with its green leaves and purple blossoms, added the final touch of texture and color.

Demonstration 3

The Pier at Guano Dam

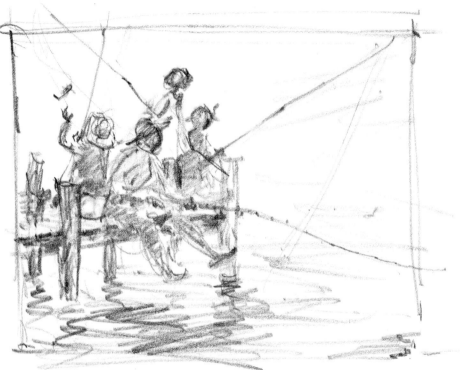

One of several sketches made before deciding on the final composition.

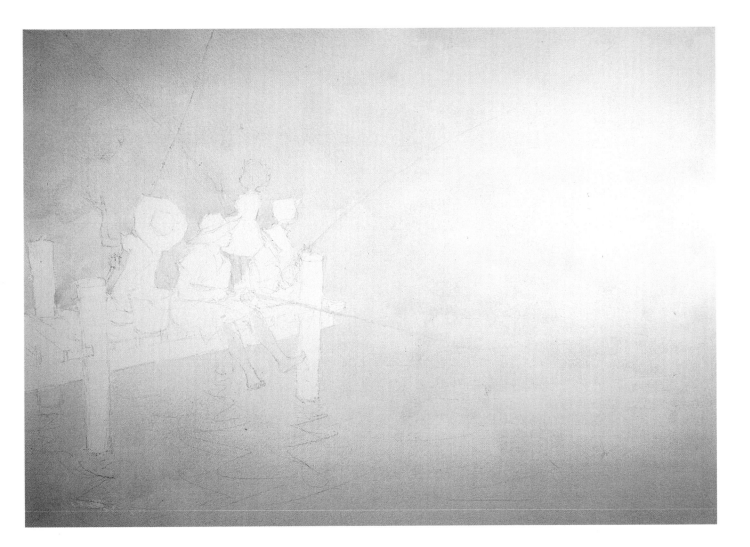

Stage I:

In the penciled-in composition based on the thumbnail sketch the figures have been drawn more heavily than usual so they will show up more clearly in the photographs depicting the painting's stages.

The figures are drawn in quite completely, but I have not dwelt upon the detail of faces, hands, etc. I prefer to accomplish this detailing with a brush as I go along.

The painting was started with a continuous wash of color for the sky and the water, with no horizon showing. I used mostly a 1½-inch flat brush. With fingers crossed, I decided against doing any masking (except for the canepoles), as I felt the areas to be kept white would be simple enough to paint around.

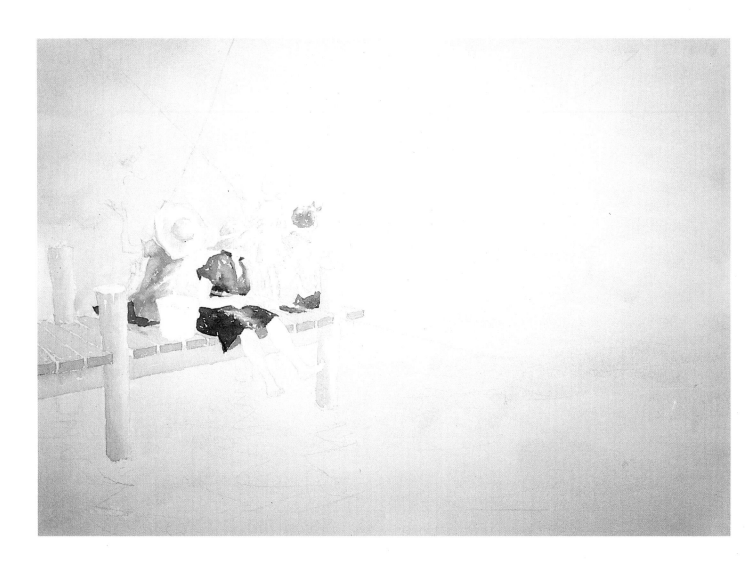

Stage II:

The canepoles have been masked. The background was a mixture of cerulean blue with enough yellow ochre added to give it a slightly greenish cast. This mixture tends to separate on the paper, producing an uneven mottled appearance. This effect, however, is atmospheric, suggesting a sunny and somewhat steamy Florida day.

I worked rapidly, cutting around various white areas and painting right through some darker spots, such as the little girl's head and the feet and legs of the seated woman. This blue wash painted through the skin areas enables me to form a cool highlight when I do the dark skin tones later on.

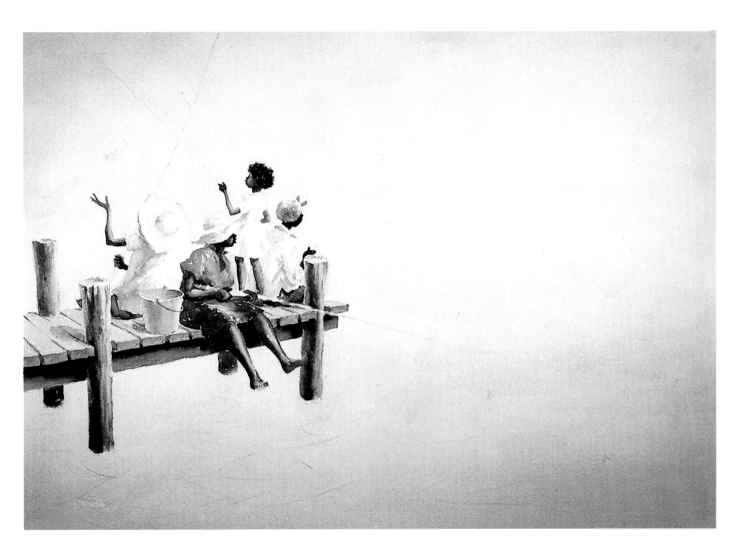

Stage III:

I next worked on the dock and the figure groups to establish some of the values, and to see the beginning of my pattern of lights and darks. I erased the bucket and moved it further to the right, so that it overlaps the figure of the seated woman a little more.

The dock is made of weathered lumber, and I gave it an initial light wash of warm gray made from burnt sienna and ultramarine blue. These two colors mixed in various proportions will produce a range of grays, from a very warm gray with the burnt sienna dominating, to a cold gray with the ultramarine blue dominating. This is just for an underneath color and some texture. The final values will come later.

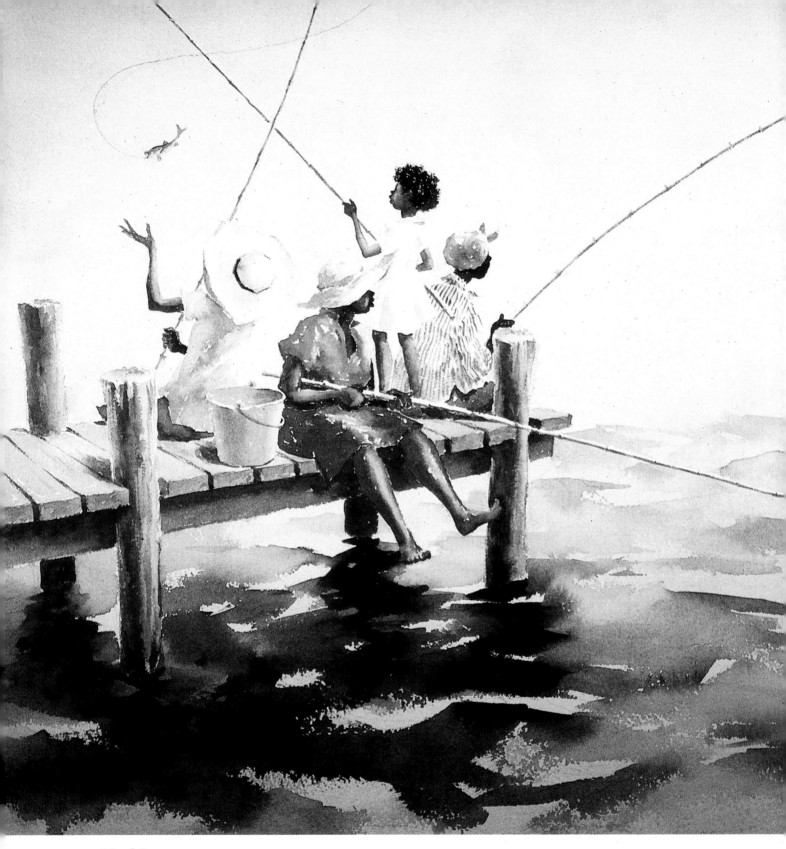

Final Stages:

The skin tones come next. Equal parts of alizarin and burnt sienna gave me a warm brown which I darkened with a small amount of Payne's gray. In modeling the arms, legs, heads, etc., I painted to the dark edge and bled the color toward the highlight area. This way, the blue which is already in place gives me the cool highlights I want.

Next, I worked on the dock, deepening the values and texturing where needed. Burnt sienna and ultramarine blue gave me the various grays that I needed. I debated with myself on the color for the plastic bucket, finally settling for this

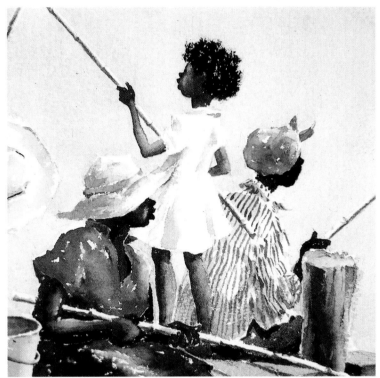

rather garish green, which they frequently are.

The finishing touches on the figures consisted of giving the girl on the right a striped blouse instead of a solid color, and adding bands to the two hats. The big job, at this stage, is the water. It might have been more sensible to have done this

in the beginning, in case it went wrong — which it easily could.

Had the water gotten out of hand at this point, the painting would have been spoiled and I would have had to start this whole demonstration over. However, I never like to paint reflections until whatever is causing the reflections has been painted first.

I started with an intense wash of Winsor blue plus enough burnt sienna to gray it slightly. Using a 1½-inch flat, I placed a few bold strokes in the foreground. I quickly softened some of the near edges, letting the waves blend into each other and trying to establish a rhythmic pattern.

I worked rapidly, using a 1-inch flat brush, handling the somewhat smaller waves up under the dock and in the middle distance in the same fashion.

While all this was still wet, I charged a darker mixture under the dock. When it was dry, I gave a little more definition to the reflections of the pilings with a still darker and warmer mixture.

Everything seemed to have been done, except for the canepoles, so I removed the masking and painted them in.

Demonstration 4

A Florida Fishing Bridge

Stage I:

A considerable amount of time has been spent in the drawing stage here. Bridges are difficult subjects from the standpoint of perspective. This, coupled with the fact that I was taking a number of liberties with the actual bridge in order to improve the setting for the figures, created extra problems. The drawing was worked out on tracing paper before being transferred to the watercolor paper.

I generally avoid masking as much as possible, but here I felt it necessary to cover those figures that would be against the dark background of the distant trees.

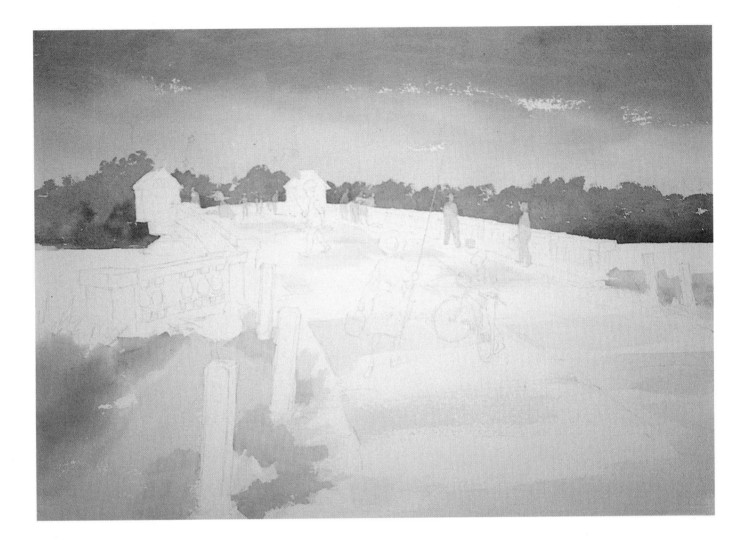

Stage II:

I put the sky in first, starting with a wash of raw sienna with a touch of Winsor blue along the horizon, and changing to pure Winsor blue for the upper part. I allowed it to come below the tree tops, but was careful to soften this lower edge to avoid the possibility of a hard line showing through later washes.

Next, I put a few light tones in the foreground and a few light strokes of gray to indicate the surface of the bridge. I planned to leave quite a bit of white paper on the road surface behind the figures.

By this time, the sky is dry and I can paint in the background trees. The green is a half-and-half mixture of ultramarine blue and new gamboge plus a little burnt sienna.

I painted the tree background as a simple, flat wash without detail to avoid conflict with the foreground figure detail yet to come. I used the side of my brush against the rough paper for the top edge of the tree line.

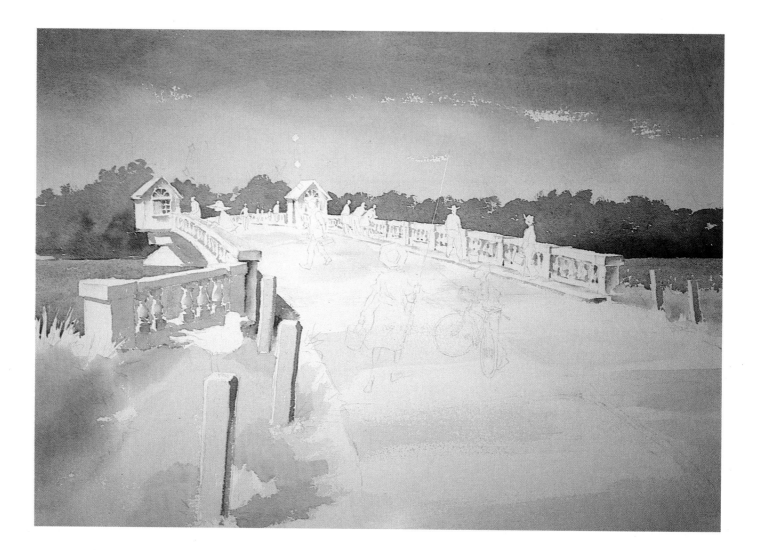

Stage III:

We continue to work on the setting for the figures. The bridge requires quite a bit of detailing, so this comes next. I try to keep the treatment of the bridge railings as simple as possible, although they are actually rather ornate. The gate houses are also treated simply, so that they won't detract from the figures.

The concrete posts at the bridge approach are painted along with the bridge detail. With most of the bridge defined, I can now paint the water.

I am depending upon the water, which is a brilliant turquoise, to add a bright color note to the painting. I used cerulean blue and new gamboge to achieve this color.

When the water is dry, I remove the masking from the figures. Now we are ready for the next stage, which will include the start of the figures.

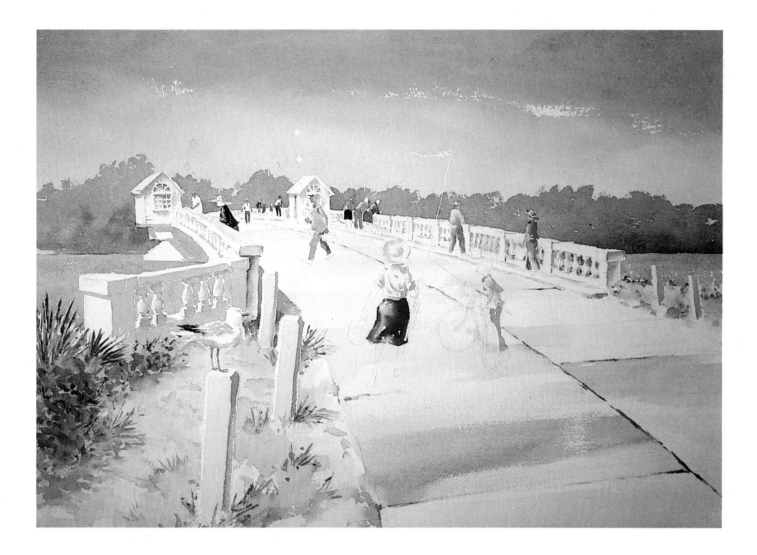

Stage IV:

Using raw sienna and Winsor green for the light greens, and burnt sienna and Winsor green for the darks, I roughed in the foliage and grass in the lower left. I also finished the sea gull perched on the concrete post.

Most of the painting areas surrounding the figures have been established, and I can now start the people themselves.

At this stage, I simply blocked in the colors without getting into any detail. I was interested only in the distribution of colors, spotting them where they would work out the best. Until now, I have used nothing but retiring background hues, but with the addition of these stronger and brighter colors, the whole appearance of the painting begins to change.

After the colors were in place, I again turned my attention to the roadbed, adding the dark streaks across the foreground, indicating the center line and a few other dark accents.

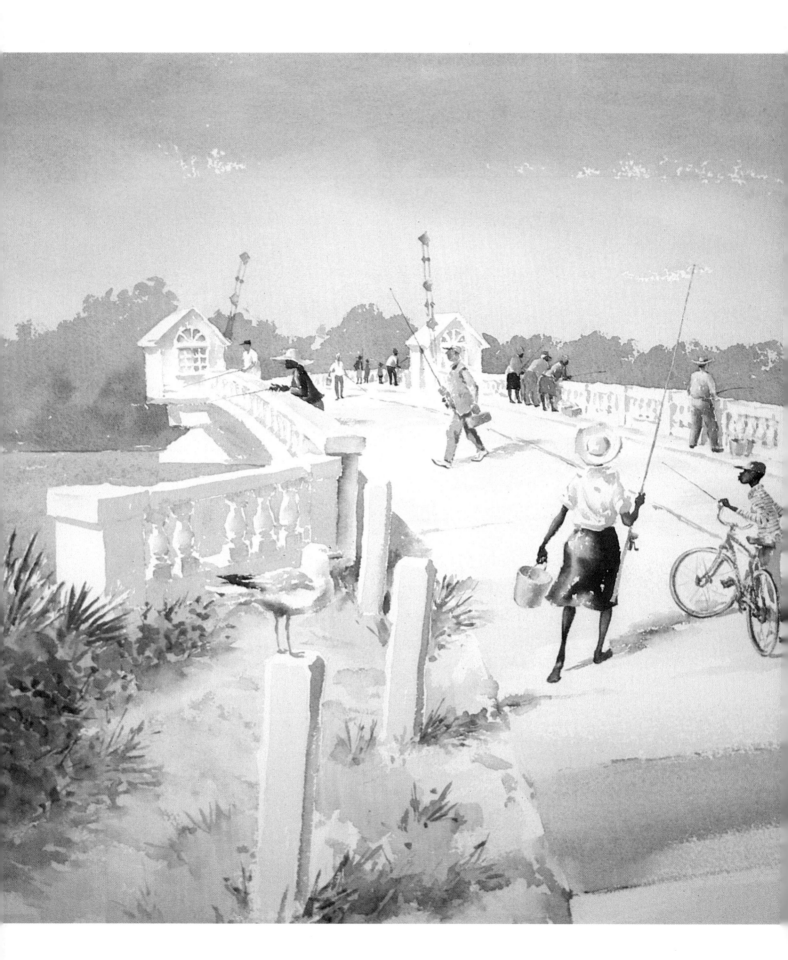

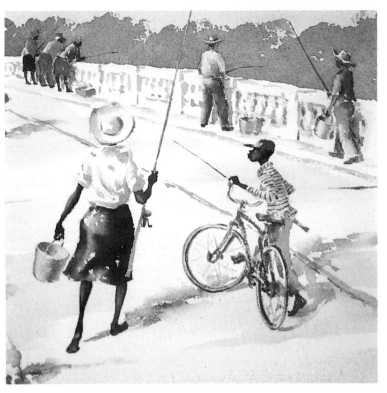

Stage V:

This is the finishing or dessert stage of the painting. The figures have already been blocked in and the color distribution decided. From here on, most of the work will be completing and adding final detail to the figures.

I carefully painted in the head of the boy on the bicycle. As with the figure in the "Guano Dam" demonstration, I first put in a touch of cerulean blue to give me the skin highlights. Then I built the rest with equal parts of alizarin crimson and burnt sienna plus a little Payne's gray to darken the mixture.

The same procedure and colors were used in completing the foreground woman. Next, I touched up the smaller, more distant figures and checked for any missing detail.

The cast shadows of the figures are an important addition. Even though cast shadows have defined edges, I softened them. I felt that any additional hard edges would create a conflict with other detail. One important function of cast shadows in a scene of this kind is to anchor the figures to the ground.

I next put in the drawbridge gates and then made sure that all the figures had their fishing rods. The yellow line was a final bit of detail, and the painting was done.

Demonstration 5
Fishing Boats, Jamaica

Thumbnail composition sketch.

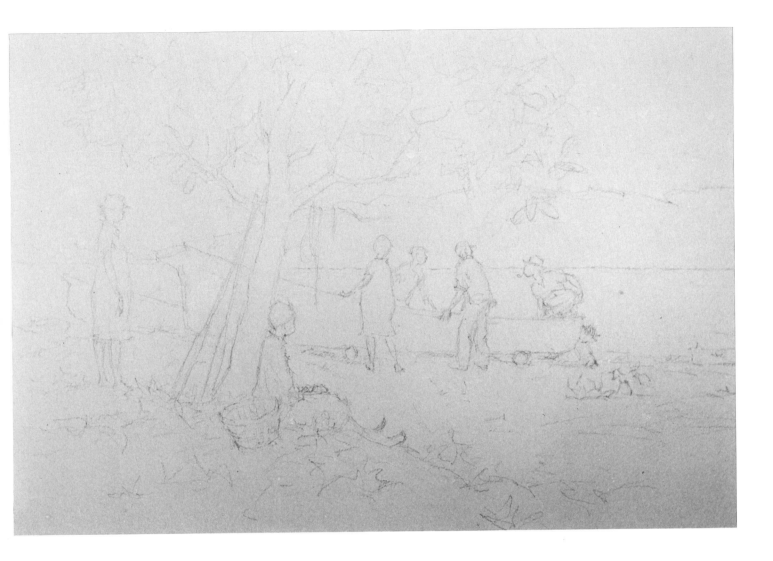

Stage I:

This stage is simply the pencil drawing. Unlike some of the other demonstrations, the drawing in this instance didn't have to be precise. I was able to draw directly on the watercolor paper, referring to my small thumbnail sketch shown here.

Once the scene was set down on the water-color paper, it was a matter of working on the figures a little to make sure that the action and anatomy were as planned.

At this stage, I would normally do any masking that was necessary. Here, however, I foresaw no problems in painting around any of the areas I would want to save. Whenever it is possible to avoid masking, I feel that the resulting watercolor benefits by having done so.

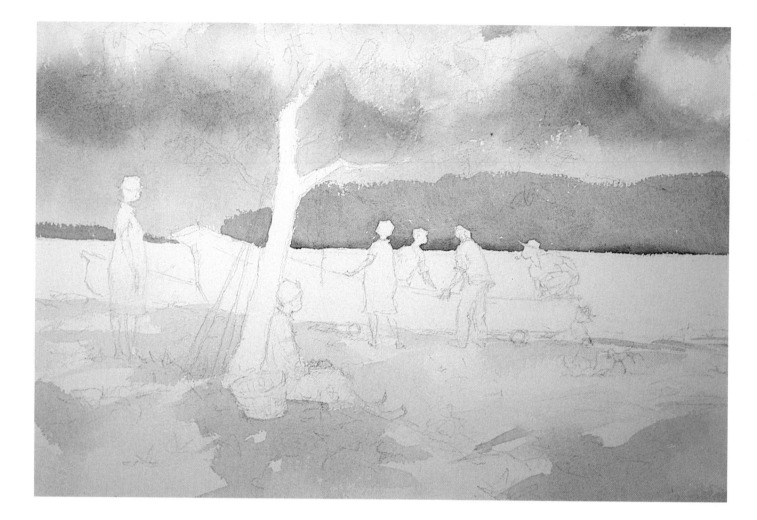

Stage II:

The first logical step was to handle as much of the background as possible. On this basis, I painted in the sky, starting with a touch of cerulean blue at the horizon. The gray undersides of the clouds were approximately equal proportions of cerulean blue and burnt sienna. Patches of pure cerulean formed the upper edges of the clouds.

The next element was the green headland across the bay. For this I used a mixture of equal parts of new gamboge and ultramarine blue. I purposely avoided texturing or detailing here, as I wanted it to remain in the distance and not interfere with the foreground detail. The far distant shore to the left was pure Winsor violet.

My plan was to leave the foreground broken up with a strong light and dark pattern of shadows and other clutter. At this point, I simply worked in the lightest of colors that would be involved.

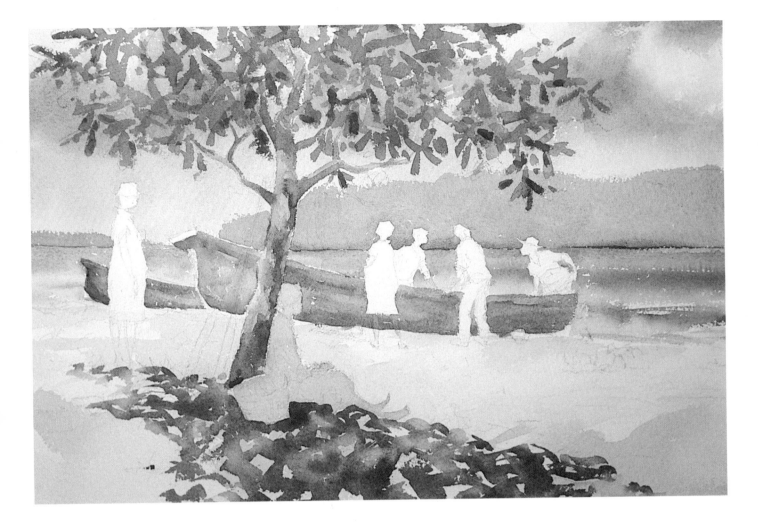

Stage III:

I now blocked in the boats and the tree. The large boat, subject to further modeling and texturing, was painted with a warm tone of burnt sienna and ultramarine plus touches of alizarin added last.

The figure seated under the tree would be in complete shade. Because of this, I put a wash of Payne's gray over the entire figure. This was to insure a complete lowering of values for the entire figure.

The tree was an almond and had rather large, oval-shaped leaves. I tried to indicate their character with a pattern of blunt brush strokes using a somewhat worn #8 round brush, concentrating at this stage on the light and bright greens. For its trunk, I used mixtures of burnt sienna and ultramarine blue in varying proportions.

The water came next. I used streaks of pure cerulean blue, new gamboge and Winsor blue allowing their edges to blend on the paper in an attempt to capture the brilliance of the Jamaican waters.

I then turned to the area of shadows under the tree. Ultramarine blue with a touch of alizarin and grayed with a little burnt sienna gave me the value and color I wanted. I used a criss-crossing of brush strokes, softening a few edges to create the dappled effect.

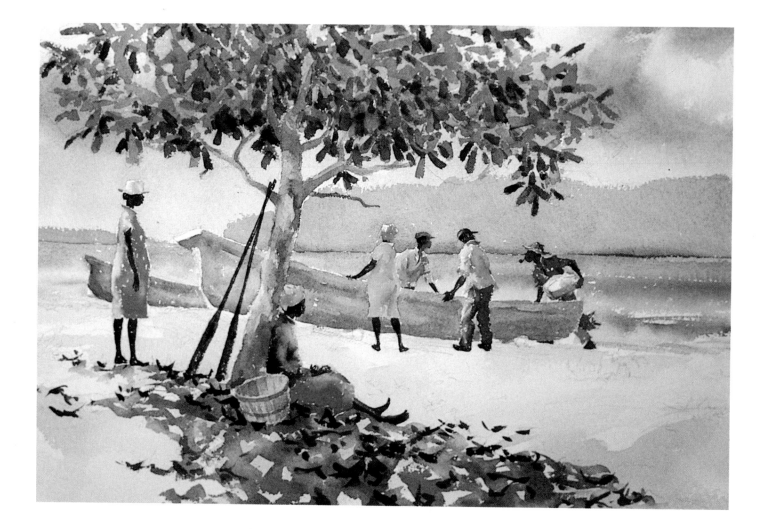

Stage IV:

At this point, the painting consists mostly of middle values. This is because of the type of subject and of the painting approach — a combination that makes a preliminary sketch important.

The sketch provides a blueprint of the light and dark pattern and keeps me on track throughout the various stages. I am now ready to start shaping things up by adding stronger values and colors.

I chose to block in the figures first, to establish some of the dark accents and bright colors at the same time Using permanent rose for one and a green made of new gamboge and Winsor blue for the other gave me the colors for the two standing women.

I decided to paint the woman under the tree with darker colors, feeling that her silhouette shape — combined with the tree trunk and tree shadow — would provide a strong, dark shape for the foreground.

A scattering of dead leaves under the tree added more darks and some interesting texturing. The oars leaning on the tree added to this dark texturing. To give more solidity to the foliage mass, I added more darks to the under side. This was done by brushing in mixtures of burnt sienna, yellow ochre and violet in approximately equal proportions.

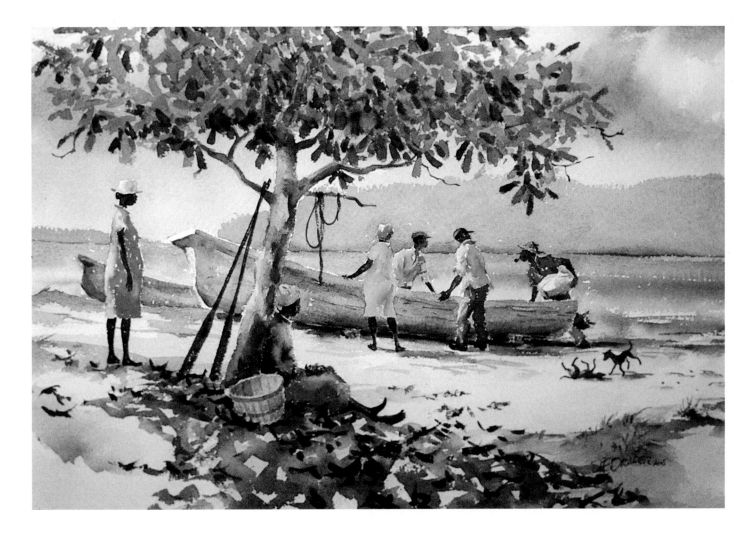

Stage V:

Quite a bit remains to be done. The ground has to be modeled and textured in such a way as to help concentrate attention on the area of the figures at the boat.

This was done by brushing in mixtures of burnt sienna, yellow ochre and violet in about equal proportions for the bare earth. Patches of grass added more texturing.

The frolicking dogs were added. They actually were present and I felt that they contributed to the feeling of the scene.

The dark shadows under the boat, the people and the dogs helped to tie all the elements together. A few final touches — the small branches on the tree — and the painting was finished.

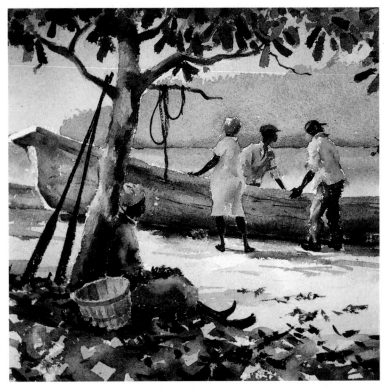

Demonstration 6
Elephant Ride

Thumbnail composition sketch.

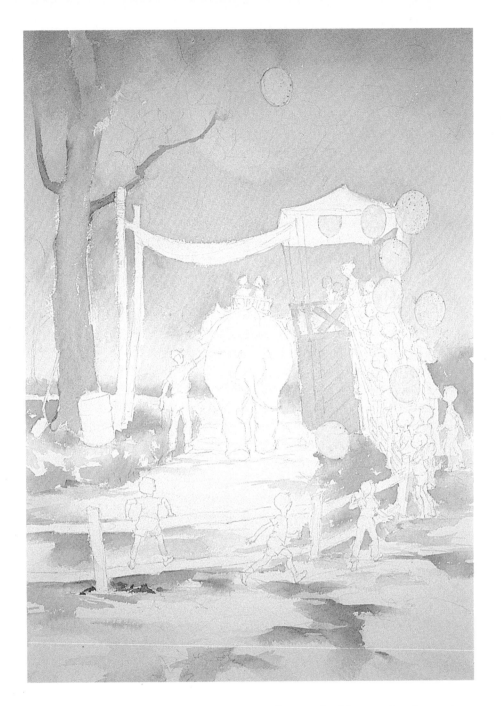

Stage I:

There are many places in this painting where a masking medium could be used. For instance, the flesh tones of the figures could be masked, but I am afraid the result would be tightness if this were done. I did mask all the balloons, though. Here, hard edges and distinct color separation from the background colors are needed.

The drawing of the figures and other detail is quite firm, and with the drawing problems out of the way, I will be able to concentrate entirely on the brushwork.

In this subject, I want my background colors to be light and bright. If this is not accomplished in the beginning, it is often difficult, if not impossible, to achieve later on.

I started with a wash of raw sienna, working it downward to provide a background for the elephant, the trainer and the boarding structure. Working the same wash upward, I converted to a pale Winsor blue for the sky, much of which will be covered by the tree foliage.

Still keeping to bright colors, I added patches of grass and then indicated the bare earth foreground, leaving quite a bit of white paper. The tree trunk and the structure were also given a preliminary wash of light color at this time.

I worked these colors in fairly closely around the figures and other detail with a large #10 brush. The large brush keeps me from tightening up around detail, which can easily happen with a subject as involved as this one.

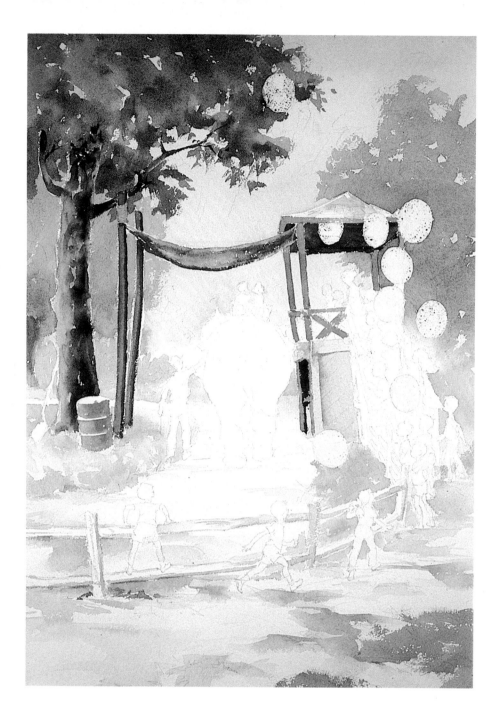

Stage II:

I continued to develop the background by adding the foliage masses. Basically, I used raw sienna and Winsor green for the light greens, and burnt sienna and Winsor green for the dark greens. I also added touches of ultramarine blue, cerulean blue, yellow and burnt sienna to create variations.

I put a few brush strokes of pure cerulean blue and pure burnt sienna on the tree trunk, and proceeded to darken the trunk with a dark gray of ultramarine blue and burnt sienna. I allowed bits of the cerulean and burnt sienna to show through the dark gray to add a little life and luminosity. At this point, I decided that a patch of green in the lower right corner would help the painting, so this was added.

Other steps were to block in the overhead shade tarpaulin, the supporting poles and the boarding structure.

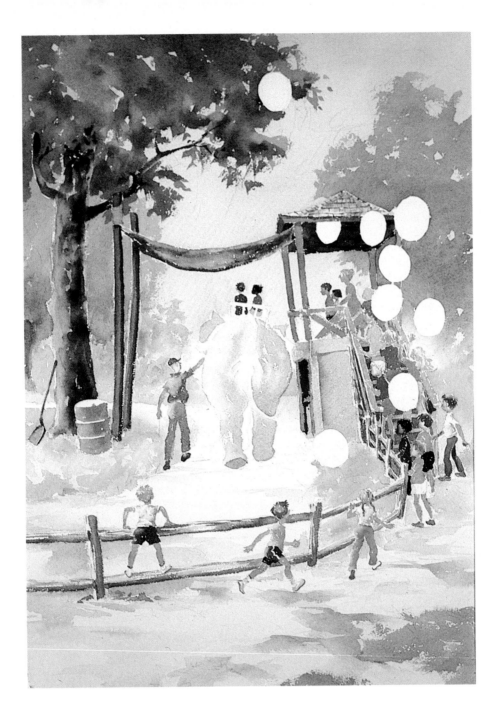

Stage III:

It was finally time to work on the figures. This consisted of blocking in the clothing colors and the flesh colors. It was a process of knitting together all of these small areas of color and value, including the details.

The elephant was blocked in with a light gray, leaving white paper highlights.

Once the figures were blocked in, I established the value of the rail fence with a fairly dark, warm gray. The detail of the shovel and the barrel under

the tree were put in, and shingles indicated on the roof of the structure.

As the final step of this stage, I removed the masking from the balloons, looking forward to the finishing touches of the final stage.

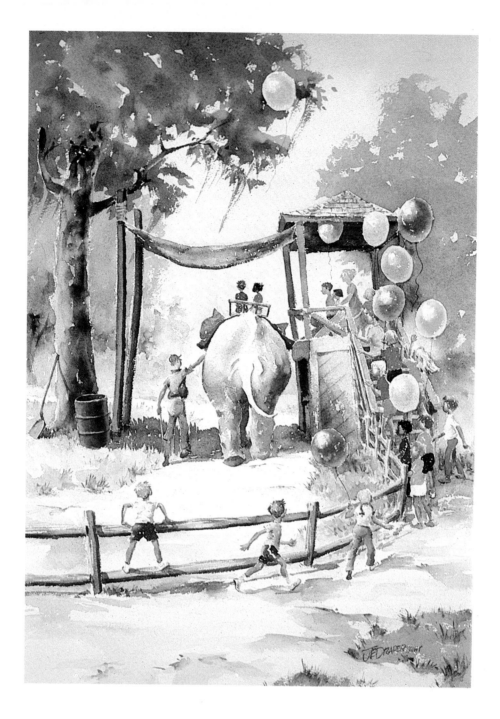

Stage IV:

The most important job here was to put in all the dominant darks. The shadow on the ground under the overhead tarpaulin, combined with the strengthened darks of the supporting poles, and the boarding structure form a frame for the focal point, the elephant.

The shadow on the ground under the elephant was a mixture of ultramarine blue, plus small touches of alizarin and burnt sienna. Using this same color, I added shadows on the split rail fence and on the ground under it. I also indicated shadows under the children's figures.

A dark, warm gray was used for further modeling on the elephant. Next, I worked on the figures one by one, modeling the flesh tones and the clothing colors. I purposely left most of the figures featureless. The figure of the elephant trainer was handled in the same way.

Now it was time to put in the bright colors of the balloons. For the sake of brightness, I kept each balloon color as pure as possible. Permanent rose, permanent violet, Winsor red, cadmium orange and cadmium orange plus Winsor red, new gamboge and Winsor green were used.

The elephant's blanket, of cadmium red, added another bright color. Spanish moss in the tree and some texturing of the grassy areas were the final touches.

Detail from *Elephant Ride*.

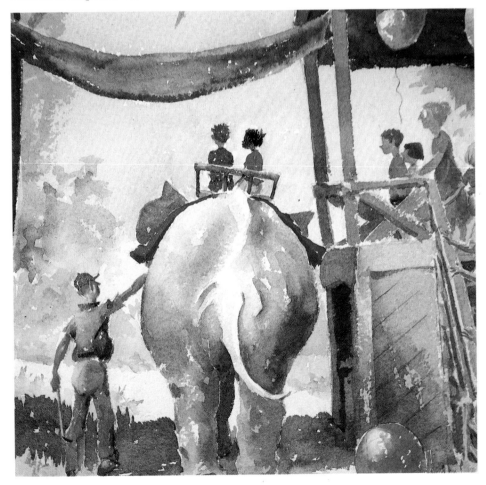

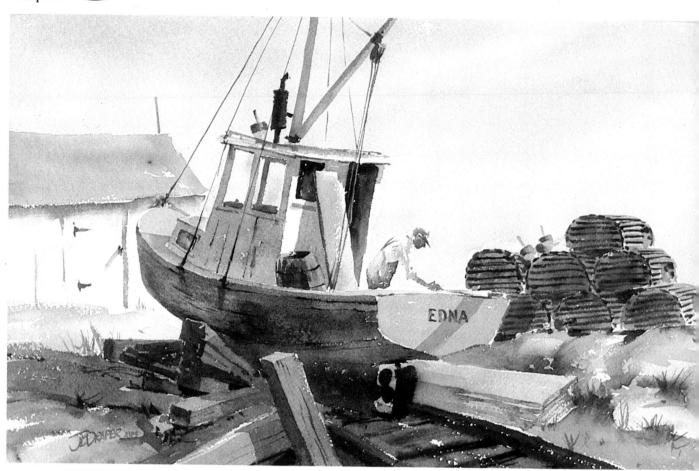

Edna
14 x 21 inches

Collection of Mrs. J.A. Conway

This subject, painted in Maine, could have been just another boatyard composition. To me, it seemed to need a figure — so I invented one as I painted.

Gallery

Painting has always been a pleasurable experience for me, providing a release from the pressures of art direction. Lately, it has been the painting rather than the art direction that has provided my livelihood. The pleasure remains.

My paintings do not always involve figures, as this book would suggest, but I enjoy including people in many of the scenes that I paint. The pages that follow contain a random collection of paintings that include figures in one way or another. Sometimes the figure will be important, and at other times incidental to the composition. In all cases, I had fun doing them.

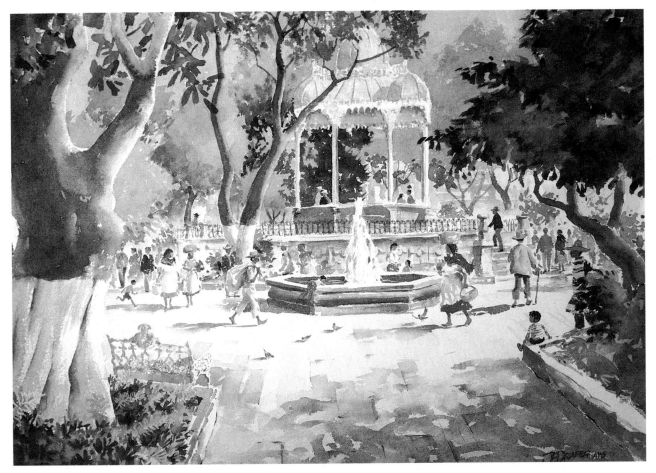

The Zocalo in Oaxaca, Mexico

21 x 29 inches

The central square is a busy place, where it is practically impossible to paint without attracting a six-deep audience on all sides. (This painting was done in the studio.) The trees, gazebo and other features were painted using slides for reference, with many liberties taken as to positioning, etc. The people were created from many sketches done from the vantage point of the cafes surrounding the park.

Several on-the-spot sketches shown in this book were used to populate this painting.

I spent a week or two in a hard hat, prowling the shipyard and sketching. I did many rough pencil sketches and took many slides for final reference. With this kind of a commission, accuracy is important. The end product was several paintings for Atlantic Marine's collection.

These are the space shuttle's booster recovery ships being built. A companion to this painting is on page 58.

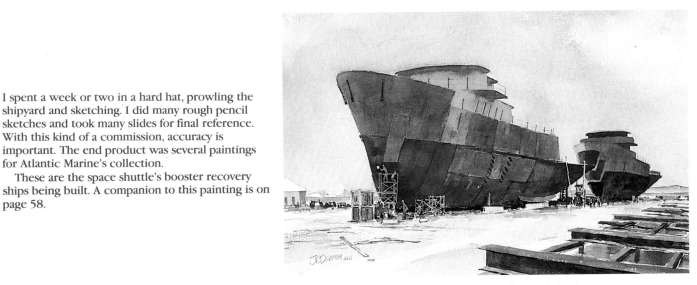

Shipyard II
14 x 21 inches

Collection of Atlantic Marine, Inc.

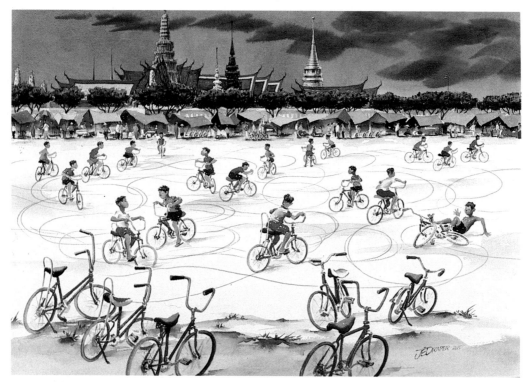

Rental Bikes, Bangkok
21 x 29 inches

This is a slightly offbeat subject but an experience I wanted to capture. It's the weekend market in Bangkok. Youngsters can rent bikes for an hour or so of frantic riding in the dusty field. The contrast of the Grand Palace in the background to the wild activity in the foreground was the challenge. There was a lot of drawing work in this, and before it was finished I had had my fill of drawing bikes.

The Guru
14 x 21 inches

This was in Jamaica. The natives coming and going to hear the words of wisdom dispensed by the local guru provided interesting figure activity in a jungle-like setting.

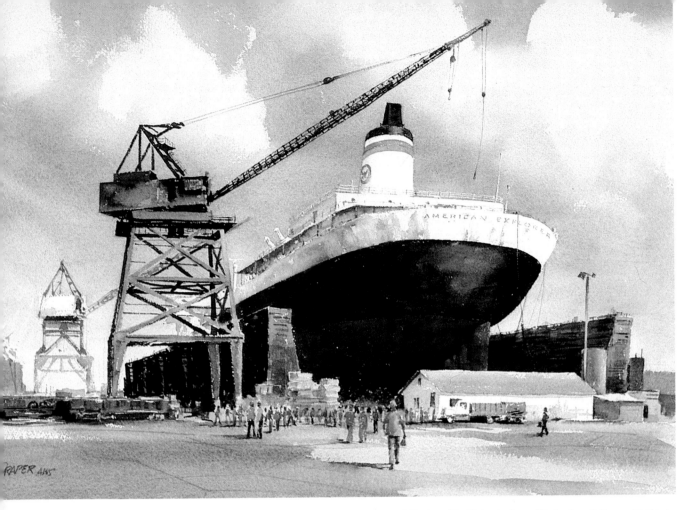

"American Explorer"

21 x 29 inches

Collection of the Marine Institute of Technology, Baltimore, Maryland.

This was a commissioned painting of the ship in drydock, presented to the institute. The figures in the setting were used to emphasize the size of the ship. A preliminary study with a different approach is shown on page 55.

The Crabbers

14 x 21 inches

The figures were developed from my collection of sketches plus imagination. The foreground water was done with a series of rapid brush strokes to capture the rhythmic pattern of surface ripples.

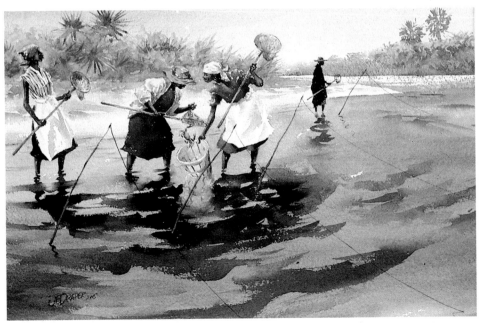

Collection of Mr. and Mrs. Ronald Katz

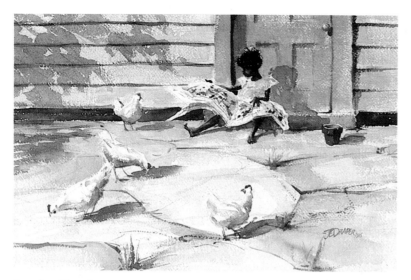

Here I relied on imagination and memory for the entire scene. The Sunday comics were used to add an interesting color note.

Sunday Morning
14 x 21 inches

Collection of Mrs. J.W. Ross

Flower Market, Lisbon
14 x 21 inches
I glimpsed this scene through the window of a taxicab. When I returned the next day to sketch, it was raining and all the flowers were covered with white plastic. I had to create the colors from memory.

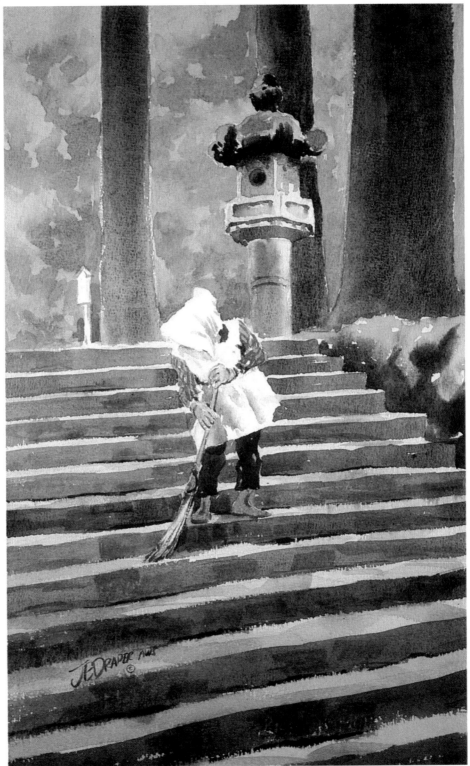

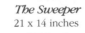

The Sweeper
21 x 14 inches

In Nikko, Japan, the dense foliage above and the mosses covering everything below created a green glow that was a painting challenge. Of course, the lady groundskeeper was the real reason for the painting.

Collection of Mr. and Mrs. George Koski

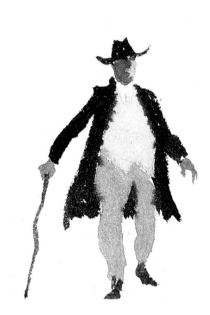

The Alfama, Lisbon
21 x 29 inches
Fish, laces, linens and meats were being sold elbow
to elbow in the canyon-like streets. I used a very
loose handling of the figures and other detail to
create a sense of movement and busyness in the
scene.

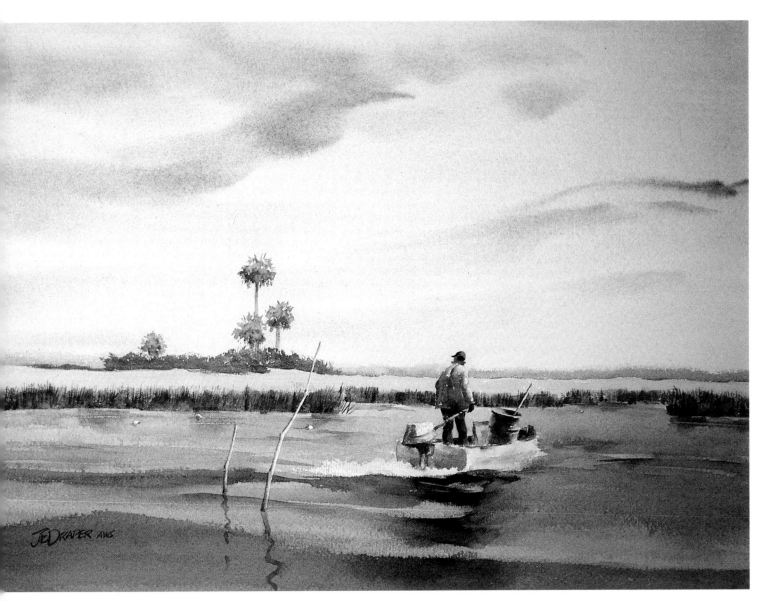

Crab Traps
21 x 29 inches

The early evening quiet of the inland waterway and the surrounding marshes sets the mood here. Indian red and cobalt blue give a violet glow to the sky, contrasting with the bright yellow greens of the marsh grass.

Collection of Mr. and Mrs. Paul Ferber

Bibliography

The Animal Art of Bob Kuhn by Bob Kuhn; North Light, Westport, Connecticut© 1973.

Animal Drawing and Painting by Walter J. Wilwerding; Watson-Guptill Publications, Inc., New York© 1946.

Animal Painting and Anatomy by W. Frank Calderon; Dover Publications, Inc., New York© 1975.

Atlas of Anatomy for Artists by Fritz Schider; Dover Publications, Inc., New York© 1947.

Constructive Anatomy by George B. Bridgman; Edward C. Bridgman, Publisher, Pelham, New York© 1923.

Drawing and Painting Animals by Fritz Henning; North Light, Westport, Connecticut© 1981.

The Drawings of Heinrich Kley by Heinrich Kley; Dover Publications, Inc., New York© 1961.

Etudes D'Animaux by M. Meheut; a portfolio of photographic prints of animal drawings, circa 1900.

Figure Drawing for All It's Worth by Andrew Loomis; Viking Press, New York© 1944.

The Human Figure by J.H. Vanderpoel; The Inland Printer Co., Chicago© 1921.

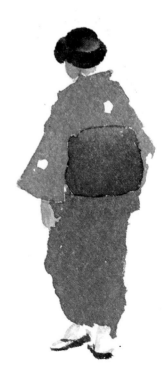

Index

Other Fine Art Books from North Light

Watercolor

Basic Watercolor Painting
by Judith Campbell-Reed $14.95 (paper)
Capturing Mood in Watercolor
by Phil Austin, $21.95 (paper)
Controlled Watercolor Painting
by Leo Stoutsenberger $15.95 (paper), $22.50 (cloth)
Croney on Watercolor
by Charles Movalli and Claude Croney $14.95 (paper)
Opaque Watercolor
by Wallace Turner $19.95 (cloth)
Painting Flowers with Watercolor
by Ethel Todd George $16.95 (paper)
Painting in Watercolors
edited by Yvonne Deutsch $18.95 (cloth)
Variations in Watercolor
by Naomi Brotherton and Lois Marshall $14.95 (paper)
Watercolor Energies
by Frank Webb $16.95 (paper)
Watercolor for All Seasons
by Elaine and Murray Wentworth $21.95 (cloth)
Watercolor Options
by Ray Loos $22.50 (cloth)
Watercolor Painting on Location
by El Meyer $19.95 (paper)
Watercolor—The Creative Experience
by Barbara Nechis $14.95 (paper)
Watercolor Workbook
by Bud Biggs and Lois Marshall $22.50 (cloth)

Mixed Media

American Realist
by Stevan Dohanos $22.50 (cloth)
The Animal Art of Bob Kuhn
by Bob Kuhn $15.95 (paper)
A Basic Course in Design
by Ray Prohaska $12.95 (paper)
The Basis of Successful Art:
Concept and Composition
by Fritz Henning $16.95 (paper)
Catching Light in Your Paintings
by Charles Sovek $22.50 (cloth)
Drawing and Painting Animals
by Fritz Henning $14.95 (paper)
Drawing and Painting Buildings
by Reggie Stanton $19.95 (cloth)
Drawing By Sea & River
by John Croney $14.95 (cloth)
Drawing for Pleasure
edited by Peter D. Johnson $15.95 (cloth)
Encyclopaedia of Drawing
by Clive Ashwin $22.50 (cloth)
Exploring Color
by Nita Leland $26.95 (cloth)
The Eye of the Artist
by Jack Clifton $14.95 (paper)
The Figure
edited by Walt Reed $14.95 (paper)
Flower Painting
by Jenny Rodwell $18.95 (cloth)
Keys to Drawing
by Bert Dodson $19.95 (cloth)

Landscape Painting
by Patricia Monahan $18.95 (cloth)
The Mastery of Alla Prima Painting
by Frederic Taubes $14.95 (cloth)
On Drawing and Painting
by Paul Landry $15.95 (cloth)
Painting a Likeness
by Douglas Graves $19.95 (paper)
Painting Nature
by Franklin Jones $17.95 (paper)
Painting with Pastels
edited by Peter D. Johnson $16.95 (cloth)
The Pencil
by Paul Calle $15.95 (paper)
Perspective in Art
by Michael Woods $12.95 (cloth)
The Pleasure of Painting
by Franklin Jones $13.95 (paper)
6 Artists Paint a Landscape
edited by Charles Daugherty $14.95 (paper)
6 Artists Paint a Still Life
edited by Charles Daugherty $14.95 (paper)
The Techniques of Wood Sculpture
by David Orchard $12.95 (cloth)

Oil Color/Art Appreciation

An Approach to Figure Painting
for the Beginner
by Howard Forsberg $17.95 (cloth)
Encyclopaedia of Oil Painting
by Frederick Palmer $22.50 (cloth)
Controlled Painting
by Frank Covino $14.95 (paper), $22.50 (cloth)
The Immortal Eight
by Bennard B. Perlman $24.95 (cloth)
Painting in Oils
edited by Michael Bowers $18.95 (cloth)

Commercial Art/Business of Art

The Art & Craft of Greeting Cards
by Susan Evarts $13.95 (paper)
An·Artist's Guide to Living By Your Brush Alone
by Edna Wagner Piersol $9.95 (paper)
Artist's Market: Where & How to Sell Your Graphic Art, (Annual Directory) $16.95 (cloth)
Complete Airbrush & Photo Retouching Manual
by Peter Owen & John Sutcliffe $19.95 (cloth)
Graphics Handbook
by Howard Munce $11.95 (paper)
How to Draw & Sell Cartoons
by Ross Thomson & Bill Hewison $14.95 (cloth)
North Light Dictionary of Art Terms
by Margy Lee Elspass $10.95 (paper)
Print Production Handbook
by David Bann $14.95 (cloth)

To order directly from the publisher, include $2.00 postage and handling for one book, 50¢ for each additional book. Allow 30 days for delivery.

North Light Books
9933 Alliance Road, Cincinnati OH 45242
Prices subject to change without notice.

—